Painting Beautiful Skin Tones With Colour & Light

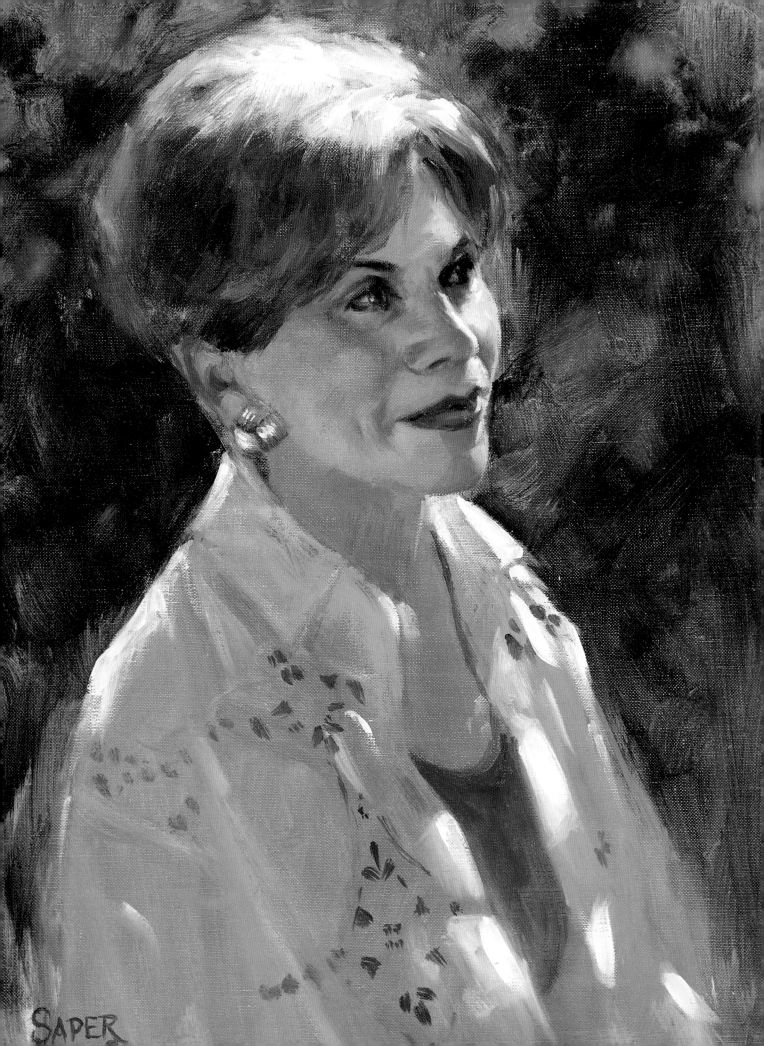

painting beautiful

skin tones

with colour & light

in oil, pastel and watercolour

Chris Saper

David & Charles

The Notion of Race

Neither anthropologists nor sociologists can agree on what constitutes race, and each group modifies its thinking on the subject over time. Ethnicity, nationality, culture, migration and intermarriage over the centuries have blurred the lines. For the sake of convenience, the four skin color groups addressed in this book follow the guidelines published by the U.S. government (which, incidentally, reconsiders its own definitions every number of years) in the Federal Register.

- **Caucasian/White (not of Hispanic origin):** Persons having origins in any of the original peoples of Europe, North Africa or the Middle East.
- **Black/African American (not of Hispanic origin):** Persons having origin in any of the Black racial groups of Africa.
- **Asian or Pacific Islander:** Persons having origins in any of the original peoples of the Far East, Southeast Asia, Indian Subcontinent or Pacific Islands. This area includes, for example, China, Japan, Korea, the Philippine Islands and Samoa.
- **Hispanic:** Persons of Mexican, Puerto Rican, Cuban, Central or South American, or other Spanish cultures or origins, regardless of race.

Acknowledgments

My deepest thanks to my family, friends and talented and generous teachers; for technical assistance, my thanks to AR3 Photography, Scottsdale; 5 Star Image Photo, Phoenix; and the GNU Group, Lafayette, California.

Special thanks to artist Ann Manry Kenyon for her warm friendship and encouragement; and to Jack Connery for believing it was just as important to teach darkroom technique as health care organization, and whose trusty old Nikkormat produced all the 35mm slides for this book. My heartfelt thanks to my North Light Book editors: to Amy Wolgemuth, Michael Berger and Stefanie Laufersweiler, for their patience and professionalism always; and to Rachel Wolf, for her humor, intellect and willingness to take a chance on a painter from Arizona.

A DAVID & CHARLES BOOK

First published in the UK in 2001
First published in the USA in 2001 by North Light Books, Cincinnati, Ohio

Copyright © Chris Saper 2001

Chris Saper has asserted her right to be identified as author of this work in accordance with the Copyright, Designs and Patents Act, 1988.

A catalogue record for this book is available from the British Library.

ISBN 0 7153 1266 9

Printed in China by Leefung-Asco Printers for David & Charles
Brunel House Newton Abbot Devon

Designer: Wendy Dunning
Cover designer: Andrea Short
Content editors: Amy J. Wolgemuth and Michael Berger
Production editor: Stefanie Laufersweiler
Interior production artist: Ben Rucker
Production coordinator: John Peavler
Artwork on title page: *Sylvia*, oil, 16" × 12" (41cm × 31cm), collection of Milton and Sylvia Saper

Metric Conversion Chart

to convert	to	multiply by
Inches	Centimeters	2.54
Centimeters	Inches	0.4
Feet	Centimeters	30.5
Centimeters	Feet	0.03
Yards	Meters	0.9
Meters	Yards	1.1
Sq. Inches	Sq. Centimeters	6.45
Sq. Centimeters	Sq. Inches	0.16
Sq. Feet	Sq. Meters	0.09
Sq. Meters	Sq. Feet	10.8
Sq. Yards	Sq. Meters	0.8
Sq. Meters	Sq. Yards	1.2
Pounds	Kilograms	0.45
Kilograms	Pounds	2.2
Ounces	Grams	28.4
Grams	Ounces	0.04

Dedication

To Ron, Aaron and Alexandra, who teach me every day what real beauty is.

About the Author

Chris Saper's portraits are currently held in more than two hundred private and corporate collections throughout fourteen states and Canada. A member of the Palette & Chisel Academy in Chicago, the Pastel Society of America and the American Society of Portrait Artists, Saper has exhibited at the U.S. Senate Rotunda, the American Legacy Gallery in Kansas City, the National Arts Club and the Salmagundi Club in New York City.

Published in *The Best of Portrait Painting* (North Light Books, 1998) and *Pastel Artist International Magazine*, Saper's recent awards include the American Artists' Professional League's Director's Award in New York and the International Association of Pastel Societies' Silver Medal. Her work is also the subject of a one-hour television program first aired on Phoenix Cable in the spring of 1997.

Saper has studied with noted portraitists, including Bettina Steinke, Burton Silverman, Harley Brown and Dan Gerhartz. She holds a bachelor's degree in Fine Arts and a master's degree in Health Services Administration. She resides in Phoenix, Arizona, with her husband and children.

Visit with Saper at her Web site, www.chrissaper.com, or send e-mail to ChrisSaper@aol.com.

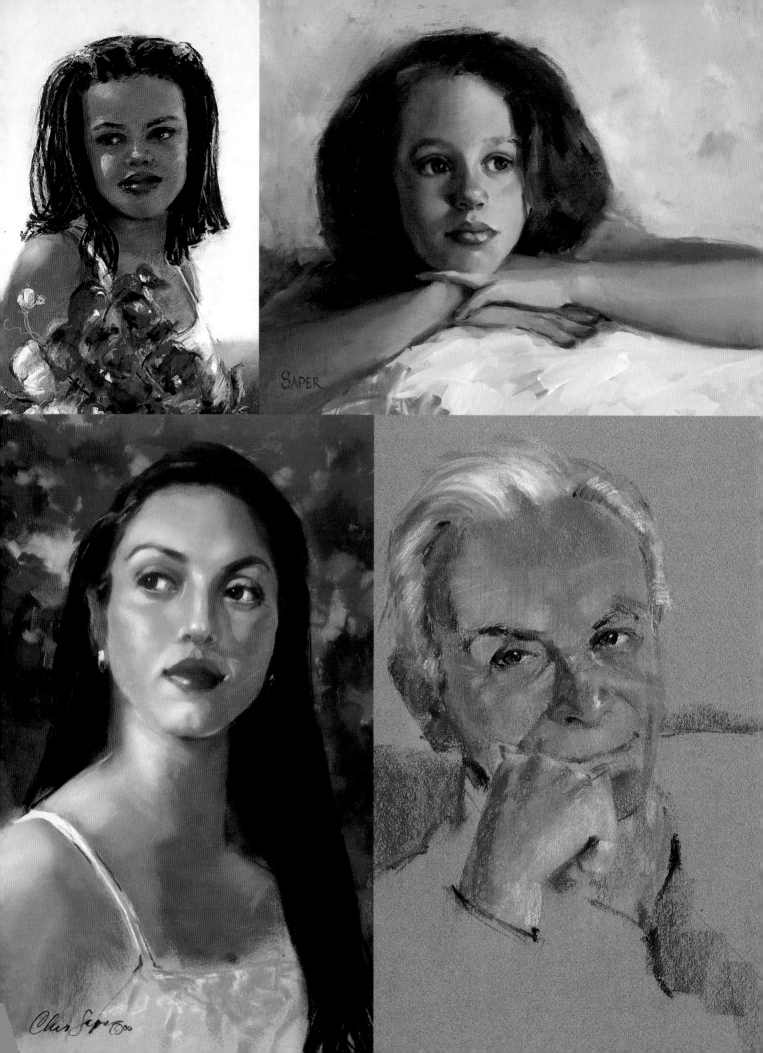

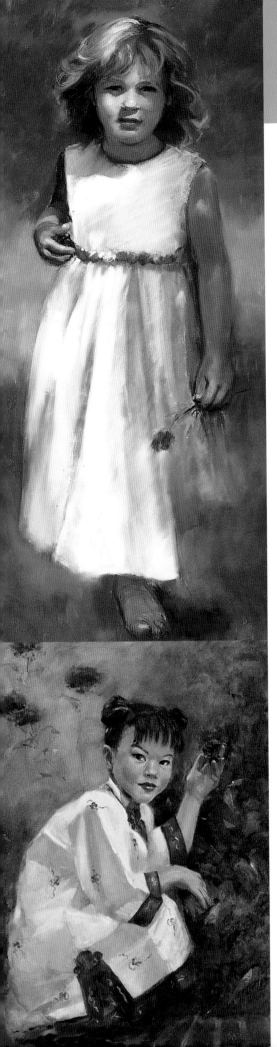

TABLE OF CONTENTS

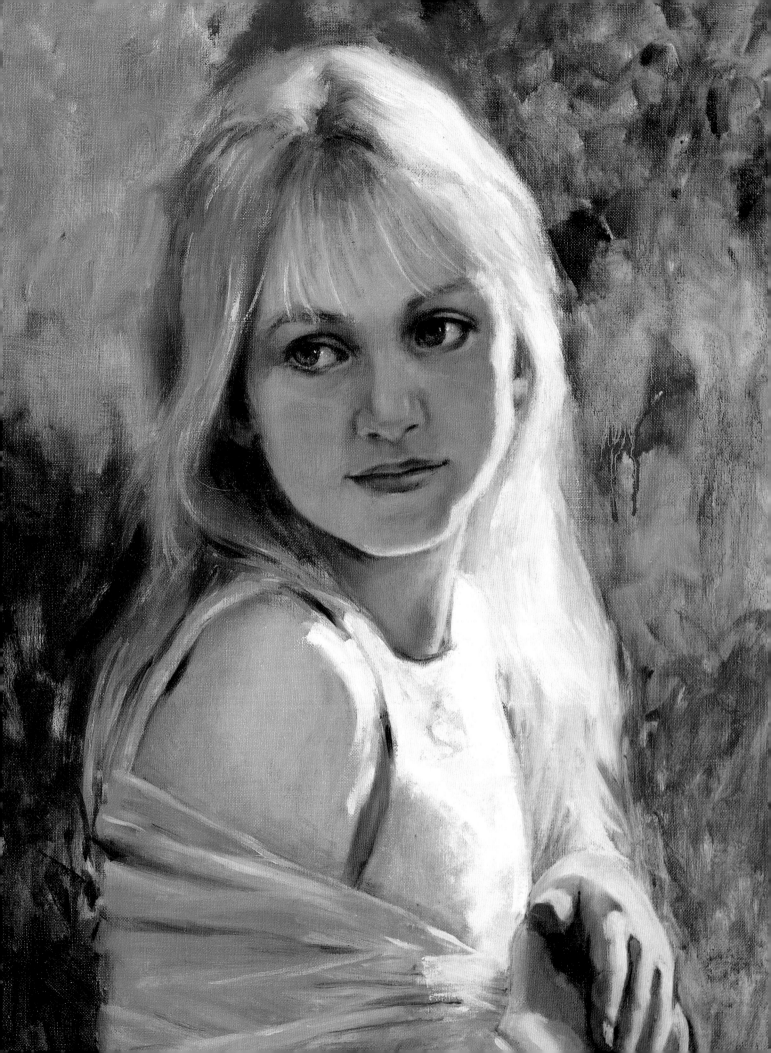

Each of us learns in different ways—some by reading or listening, some by watching, some by doing.

Since I began painting portraits ten years ago, I've sought out the advice of painters whose work I admire. Fortunately, many of those painters were also great teachers. To me, painters tend to be either intu- # INTRODUCTION

itive or academic. Intuitive instruction—"just pick out some color," "use color that expresses the way you feel"—has never helped me. But instructors who have taught me how to see—what to look for and why—have given me tools I can use for a lifetime. This book is designed to give you tools you can use, too.

Painting beautiful skin tones has more to do with understanding color and the way it is affected by light than any other factor. The principles presented here apply to any medium and do not rely on a particular style or technique.

There are no secrets to painting portraits successfully. There are simply a variety of decisions to be made. This book is structured to show you how to make these decisions in a systematic, straightforward way.

By organizing your approach to painting, you will be able to get more con- sistent results. When something goes wrong, you'll know why it went wrong and how to fix it. Perhaps most importantly, you'll free yourself to continue to grow as an artist and to be part of the most joyful work there is. Enjoy.

MADELEINE (DETAIL)
Oil on linen
18" x 14" (46cm x 36cm)
Private collection

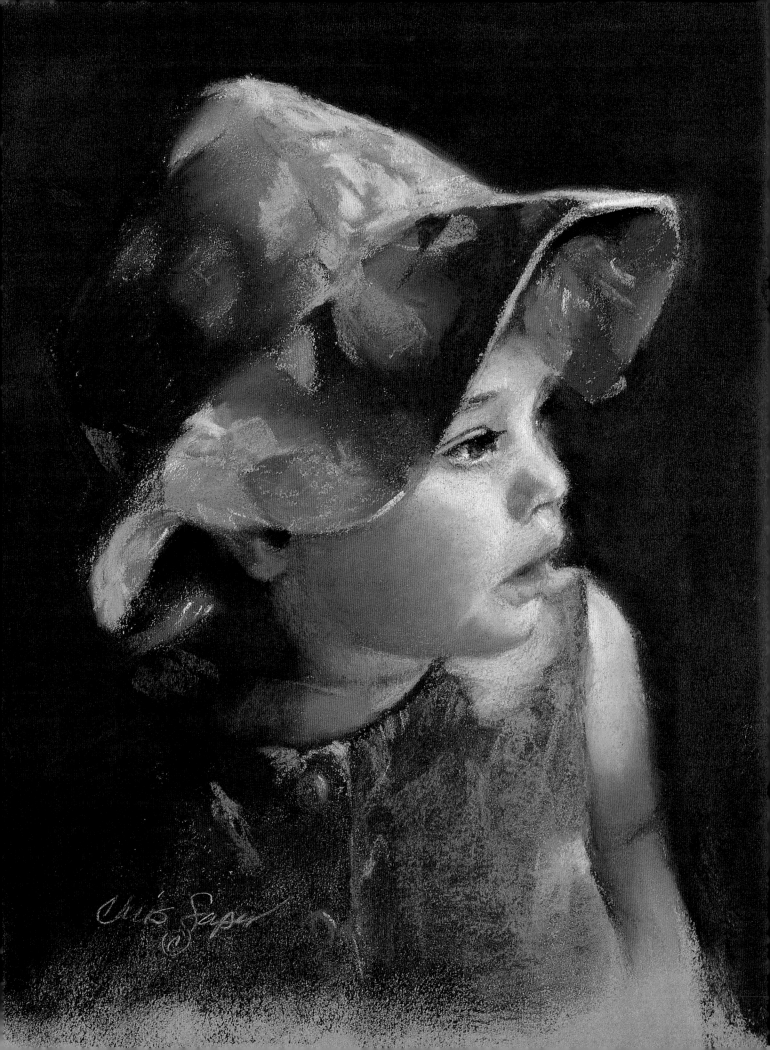

1 THE FIVE ELEMENTS OF PAINTING

There are five essential elements in every painting: drawing, value, color, composition (or design) and edges. It's important to note that all paintings contain these elements, even if we as painters try to ignore them. They simply insinuate themselves into our work by default, and generally in a disorderly fashion. Instead, consider each element and make a purposeful decision about it. Even if the decision turns out to be wrong, at least you'll have a basis for figuring out why and for making a better choice next time.

Think of a portrait as a painting that just happens to star a particular person. Without the interpretation of the artist to simplify information and decide what is important for the viewer, there's no need for a painting at all. It would be faster and easier just to take a nice photograph and be done with it.

CHAMBRAY
Pastel on Canson paper
13" x 13" (33cm x 33cm)
Collection of the artist

Drawing

While good drawing skills are fundamental to all representational art, they're most important in portraiture. Strong drawing skills result from patient observation, good training and lots of practice. Good likenesses result from accurately measuring the distance between the features and using value to show volume.

Think of your canvas as the battleground between what your eyes see and what your brain decides it knows. Let the judgment of your eyes prevail. After all, achieving an accurate likeness is an important part of portraiture, one that every portrait painter, living or dead, has spent a lifetime working toward. And though "likeness" is not the primary focus of this book, by studying the lessons in color relationships and improving your skill in rendering light and shadow, you will automatically improve your skill in achieving likeness. There are also some excellent resources noted in Appendix A (page 120) that I consider to be especially helpful.

Paint Many Paintings

My painting teacher relates a tale of his college ceramics class. The instructor divided the class into two groups for their final weeklong project. The students in the first group were told that their entire semester's grade would be based on each student producing one pot—the very best, most perfect pot possible—by Friday. The second group's grades would be based only the number of pots they could produce by Friday. Guess whose pots were better? The group with the most practice, of course!

The moral: Paint many paintings. Paint every day that you can. Maybe you'll like only a handful of the many you create. Success is made up of many small failures and the decision to challenge every one of them.

Measuring

When measuring proportions, use flat straightedge tools suitable for both photos and live model sittings. For photos, place the measuring tool directly on the photo, using your thumbnail to mark the basic unit of measurement (for example, the distance between the pupil and chin). Compare all other distances to your basic unit.

Value

Value is the relative lightness or darkness of an object, and its importance in your painting cannot be overstated. Value is what convinces the viewer that a face is three-dimensional, even though the surface it's painted on is clearly flat. It gives form to the cheek and luminosity to the eye. It creates the path for the viewer's eye to follow as it explores every corner of your painting.

Every color has a value. Imagine a photograph of a color wheel taken with black-and-white film. Red and green, in their purest intensity, would be virtually indistinguishable. However, even in black and white,

it's impossible to confuse blue with yellow. Every color can be lightened with the addition of a lighter color or white, or darkened with the addition of a darker color or black. With every lightening or darkening step, colors take on new values.

Values run from black to white and every shade of gray in between. It is the artist's job to decide what's important in each element, including value. Not only is it unnecessary to use the full continuum of values in a painting, it would be a dreadful mistake. Too many values cause the viewer's eyes to jump around in a confused and

haphazard fashion, failing to find the center of interest. The fastest, most effective way to simplify a painting is to simplify the values.

The five-value scale is a useful tool that will be used in the later demonstrations to describe how to mix or select colors.

Colors will be described both by their hue and by one of these five values: dark, middle-dark, middle, middle-light and light. When the demonstration calls for values at the ends of the value range, these colors will be described as very dark or very light.

Thinking in Black and White
Black-and-white photographs eliminate the confusing variable of color and can be invaluable when you work from photographs. In this example, the reds, greens and blues have similar values.

The Five-Value Scale
Notice that the value scale excludes black (an accent color) and white (a highlight color). Reserve the very light value for highlights or white descriptions and the very dark value for the darkest accents.

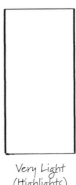

Very Light (Highlights)　　Light　　Middle-Light　　Middle　　Middle-Dark　　Dark　　Very Dark (Accents)

Color

Rich, subtle, bold, beautiful. Understanding color and how to see it will be one the most valuable lessons you will gain from this book. The thoughtful selection of a color harmony and the ability to decide what color you want will make mixing colors easier.

Color has several dimensions, which will be referred to repeatedly throughout the rest of the book. The terminology is simple and direct.

HUE
Hue is simply another word for color. Throughout this book, colors will be referred to in generic terms. Primary colors include red, blue and yellow; secondary colors include orange, green and violet; and tertiary colors, or the colors in between, will be hyphenated (red-orange, blue-green, blue-violet and so on). It's far better to describe a color as a "light red-orange" than as a "warm peachy pastel." Describing color this way is a good habit to get into because it allows you to communicate with other artists in a way they can readily understand.

INTENSITY
Intensity, or saturation, is the degree of strength or purity in a color. For example, red is most intense when it contains neither blue nor yellow, and when it contains none of its complement—green.

The term "grayed down" will often be used to describe color. Every color, when mixed with its accurate complement, will result in a beautiful, rich neutral—a complementary gray. For example, a grayed-down red describes pure red that is mixed with its complement, green. Enough green is added to diminish the intensity of the red, but not enough to create a neutral gray. The resulting color is still perceived as red in nature. Conversely, a grayed-down green describes a pure green mixed with its accurate complement, red. Enough red is added to reduce the intensity of the green, but not enough to become neutral.

The Terms of Color

Simple, direct names are used throughout to describe a place on the color wheel. Avoid descriptions such as "leaf green" or "ocean blue." There are as many interpretations of phrases like these as there are artists!

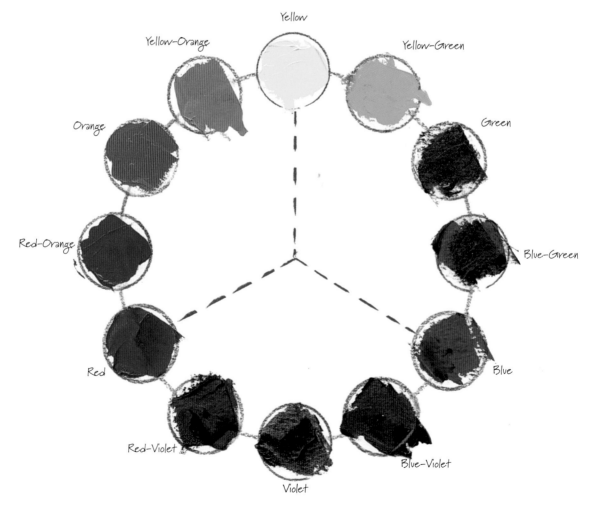

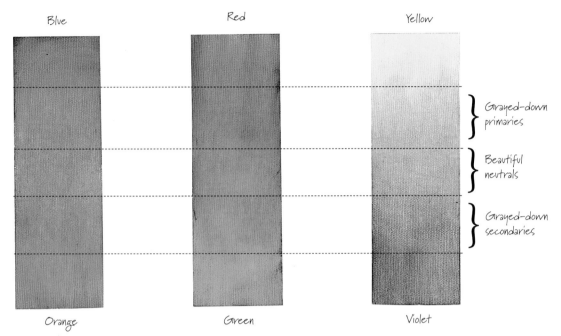

Blue Red Yellow

} Grayed-down primaries

} Beautiful neutrals

} Grayed-down secondaries

Orange Green Violet

Loaded With Color: The Gray Zone

Mixing any color with its accurate complement results in lush, wonderful neutrals. These complementary grays are automatically in harmony with your other colors, and add richness and unity to your painting. It's rare to find objects in our natural world whose colors are at full intensity (perhaps with the exception of some tropical birds), especially human skin. Objects with fully saturated colors are generally man-made.

Black Sign painter's gray White

Sometimes Say Never

Contrast the beauty of complementary gray with the cold, eye-stopping gray resulting from a mixture of black and white. *Never mix black and white to get gray for your canvas.*

TEMPERATURE

Temperature refers to the relative warmth or coolness of any given color. All colors can be mixed to create both a cool and warm version. For example, red becomes warmer when mixed with yellow; it becomes cooler when mixed with blue. The temperature of color is always relative. For example, green is warmer than blue (green contains yellow), but it is cooler than yellow (green also contains blue). In painting skin tones, the artist must constantly make comparisons. For example, is the skin on the forehead warmer or cooler than the skin on the cheek?

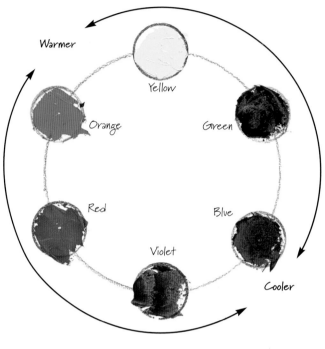

Go South to Cool Off

Colors become cooler as they move around the color wheel toward blue. Conversely, colors warm as they move toward yellow.

Temperature Is Relative

The ability of every color to take on either warm or cool qualities makes them versatile and exciting. Placing the warm version of a color next to its cool version sets up a beautiful visual vibration. This is an effective device to support the center of interest and to add energy to an otherwise boring painting.

LOCAL COLOR

Local color is the color that generally describes something. Lemons are yellow, grass is green. It's important to differentiate the local color from the color you're mixing because there are two influences that will always change local color: the color of the light source and whether it's viewed in light or shadow. Color in shadow is not a darker version of the same color in light—it is a different color. Chapter Two describes exactly how colors change so that you can paint them correctly.

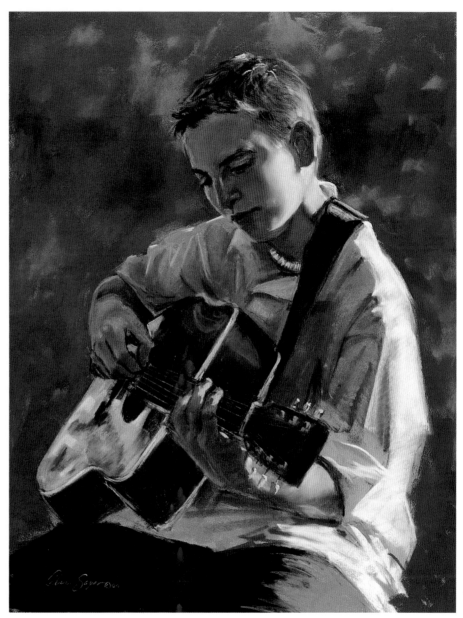

The Myth of Local Color

Sunlight lightens and warms all colors, including skin tones. Shadows are not only darker in value, but are a different color. They are cooler in temperature, incorporating blues, violets and greens in skin color. Local color is always truest along the edge where the light and shadow meet.

COMING OF AGE
Pastel on La Carte sanded paper
24" x 18" (61cm x 46cm)
Collection of Andrew and Sherry Saper

Composition

Ask most people what constitutes good design, and you're likely to get a lot of, "Well, I can't describe it, but I know it when I see it!" Perhaps the most practical working definition is the simplest: Good design is the arrangement of shapes and values in a way that *looks good*.

There are several aspects of a painting that can predictably please the eye of a viewer. *Variety* in size, shape and value should exist. The viewer also wants to see *balance*, but he wants an unequal balance. For example, the viewer is quickly bored when the center of interest is right in the center of the painting. A viewer wants to see negative space (the area around or between objects), but the spaces should be in different quantities and different shapes. The viewer wants light and dark but in different proportions. The viewer also wants variety of color, but not of equal intensity. And finally, there should always be an obvious way into the painting, or *eyepath*, for the viewer and a slightly less obvious way out.

ENTER FROM THE LEFT OR THE RIGHT

I have long held the theory that people read paintings the same way they read the printed page: in a learned visual direction, based upon their first written language. With languages written left to right, such as English, people develop a left to right default direction. Those whose first language is written right to left, such as Hebrew, or top to bottom, such as Chinese, develop respective default reading directions. Without purposeful visual direction to the contrary, I know most of my clients will naturally enter the painting from the left side.

Satisfy With Good Balance
Negative and positive spaces in equal proportion force the viewer to straddle the fence, trying to decide which shape is positive and which is negative. This leaves the viewer either confused or annoyed.

Balanced Yet Unequal
This design pleases the viewer's eye through harmony and movement. Thoughtfully pose and place the subject (as shown in the finished portrait below) early on to help prevent a design crisis at the end when it may be difficult to correct.

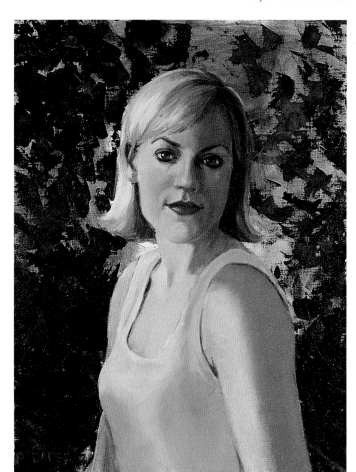

PORTRAIT OF NANCY
Oil on linen
18" x 14" (46cm x 36cm)
Collection of Mr. and Mrs. Vincent Perla

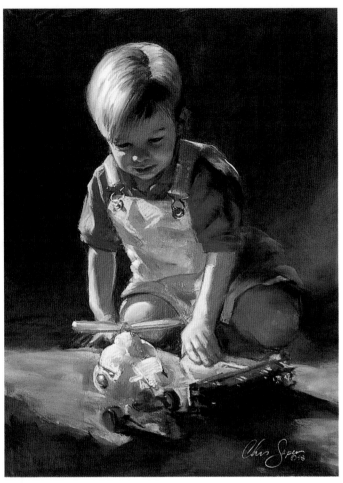

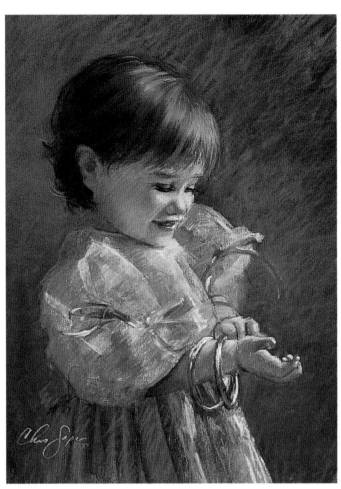

Step Right In

A visual entry gate placed at the left edge (as shown in the painting above) starts the viewer on the road to the center of interest. A left entry is natural for viewers whose first written language is read left to right. If you want viewers to enter from the right (as shown in the painting at right), you'll need to provide strong visual clues. Of course, the exact opposite is true for viewers whose first written language is read right to left.

KIPP
Pastel on Wallis paper
22" x 16" (56cm x 41cm)
Collection of the Charlton
 Family

SILVER BRACELETS
Pastel on Wallis paper
16" x 12" (41cm x 30cm)
Collection of the artist

Lead the Viewer

Make a purposeful decision about where you place the visual entry into the painting, just as you make every other decision about your portrait. Choose to either support your viewer's learned visual direction or give him clear visual clues to the contrary. Make the journey across your canvas a comfortable and pleasant one.

CREATE AN EYEPATH

Once the viewer's eyes enter the painting, give a clear path to follow to the center of interest. Eyepaths can be rectilinear (in a straight line) or curvilinear (in a curved line), but they should not be both. While a rectilinear eyepath may be suitable for a cityscape, a curvilinear eyepath is far more suited to a human subject. An eyepath with gently curving loops, echoing the natural curves of a person's face and body, will predictably please the viewer.

Eyepaths can be either clockwise or counterclockwise, but they should not be both. The most successful eyepaths encourage the viewer to grip the subject with his eye, returning again and again to the center of interest you have chosen.

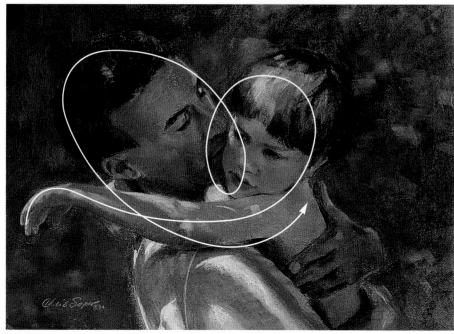

A Flowing Eyepath
Gentle curves and flowing loops make more suitable eyepaths for portrait and figurative work.

Choose Your Direction
Use design elements to create a clockwise or counterclockwise eyepath. The painting on the left shows clockwise movement, while the painting on the right demonstrates counterclockwise movement.

MY CAT COTTON
Pastel on La Carte sanded paper
22" x 16" (56cm x 41cm)

ALEXIS (DETAIL)
Pastel on Wallis paper
22" x 16" (56cm x 41cm)
Collection of Dr. and Mrs. B. Larsen

Edges

Edges occur wherever shapes meet, such as between a subject's hair and the background, the face and hair, the collar and throat, and shadow and light. Edges are all around us, and the artist's ability to manage the edges is often the element that separates the amateur from the master.

In a painting, edges accomplish two important tasks. First, they control the viewer's eye movement over the canvas, acting like traffic signs. The eye flies to sharp edges and coasts gently over soft ones. As the eye travels and comes to a lost edge, the viewer finds comfort in seeking out the place where it is found again.

Second, edges are necessary to support your center of interest, which is the entire point of your painting. Sharp edges at or near your center of interest act like a rubber band for the viewer's eye, calling it back over and over to gaze at what you want him to see the most.

Edges have four different dimensions: hard, soft, lost and found. *Hard edges* can be found in cast shadows, closest to the object casting the shadow. They are characterized by easy-to-see boundaries, smooth textures and areas of strong contrast.

Soft edges are fuzzy and less distinct. They are commonly observed where an object has a form shadow (as opposed to a cast shadow), where textures are uneven and where adjacent shapes are similar in value.

Edges are *lost* when a shape's value is equal to the value of the shape it is next to. They are *found* again when one of the values changes.

FINDING SHARP EDGES

It's much easier to see edges working from life than from photographs. In working from life, one of the best ways to identify your hard edges is to close your eyes, open them briefly to look at the model, then close them again before you have time to focus on the subject. Your visual memory is your guide because the areas of highest contrast will remain as an afterimage. Due to the way a camera focuses, photos will give you false edge readings. Later chapters will teach

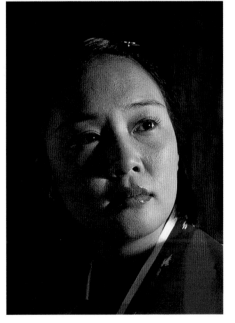

Place Your Hardest Edges Near the Center of Interest

To enable the viewer to find the center of interest and to ensure that the correct part of your painting will command the most attention, place sharp edges at or near the center of interest when possible. Sharp edges that also have strong value shifts work even better.

CATHERINE
Pastel
22" x 16" (56cm x 41cm)
Collection of the Hemingway Family

Look for Hard and Soft Edges

Differentiating between the harder edge of the shadow cast by the nose on the upper lip and the softer edge of the form across the bridge of the nose or across the curve of the cheek will give your portrait energy and life. Also, conveying edges in texture, especially in clothing and hair, will give the viewer other important visual clues.

Lost and Found

Look for opportunities to lose and then find edges, even when they're not glaringly obvious. It's usually easy to lose and find edges in the softness of hair. The nature of pastel especially lends itself beautifully to variations in edge quality.

you how to deal with this limitation. You'll also learn why it's helpful to develop an edge plan early on in a painting. An edge plan will return control of your canvas to you. "Treat an edge like a story," says noted artist Richard Schmid. "Stretch the truth as far as you'd like without telling a lie."

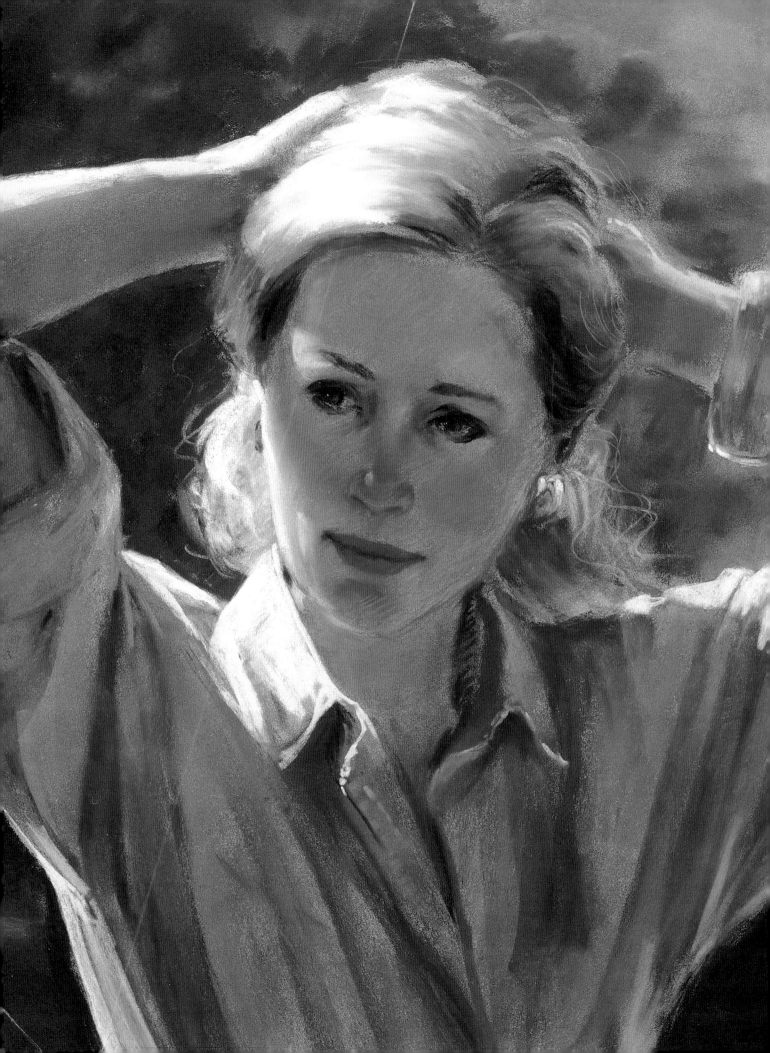

2 THE COLORS OF LIGHT AND SHADOW

Light carries the color in a painting, but shadows carry the painting. Light transforms color and is the very basis for painting beautiful skin.

Determining the color of light that falls on your subject and whether your portrait is about light or shadow are the first and most important color decisions you must make. Light lends its color temperature to everything it touches. Everything left in shadow takes on the opposite temperature. For the lights in your portrait to bring your subject to life, they need to rest on a solid foundation of shadow.

There are straightforward rules that govern the temperature, or color, of light. These rules explain colors that you can observe, give guidelines for color that you might deduce and provide structure when the color of light is strictly the artist's choice. By developing a sound understanding of the colors of light and shadow, the principles of color temperature will become powerful tools for you. Decisions about how to see, mix and paint skin color will become much easier to make and to execute.

LINDA (DETAIL)
Pastel on La Carte sanded paper
18" x 26" (46cm x 66cm)
Collection of Linda Tracey Brandon

Making Friends With Kelvin: The Color and Temperature of Light

Like color, visible light can be warm or cool, depending on its source. The temperature of light is measured on the Kelvin (K) scale, and represents color ranging from red-orange (about 2200K) to blue (about 12000K+). As the color of light becomes more red, the color of shadow becomes cooler. It's far more important to understand the relative temperature of light than to worry about precise measurements.

Blue Noon

Reddest at sunrise and sunset, sunlight takes on a neutral color at 10 A.M. and 2 P.M. at approximately 5500K. Normal daylight film is designed to read color accurately at 5500K. Match your film to the temperature of your light for the best color results. (*Note:* Because there is not a single standard for the manufacturers of fluorescent bulbs, those lights can vary widely.)

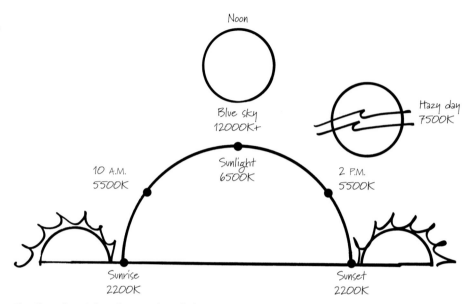

The Changing Color of Natural Daylight

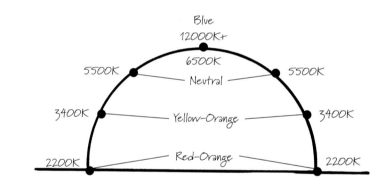

The Color of Light and Kelvin Degrees

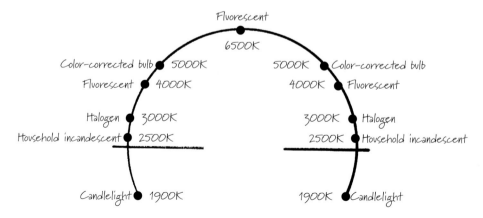

Common Artificial Lights and Their Kelvin Degrees

Direct Sunlight

Sunrise/Sunset

Color: red-orange
Temperature: approximately 2200K
At sunrise and sunset, sunlight is at its reddest. It's at the lowest angle, passing through dense layers of the atmosphere.

Mid-morning/Mid-afternoon

Color: warm neutral
Temperature: approximately 5500K
In its daily arc, the sun reaches approximately 5500K at 10 A.M. and 2 P.M., losing its red cast as it rises in the sky. This temperature is also the visual dividing point for the relative temperature of light. Higher Kelvin degrees represent cooler-colored light; lower Kelvin measurements represent warmer-colored light. Our eyes tend to perceive 5500K as neutral in color.

Noon

Color: warm white
Temperature: approximately 6500K
As the sun rises in the sky, the temperature of light also rises, becoming bluest at its peak. After noon, the temperature of light begins its descent, again reaching approximately 2200K at sunset.

Colors and Shadows

Warm lights produce cool shadows.
Cool lights produce warm shadows.

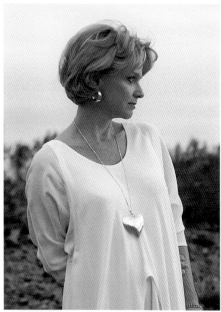

Sunset Distortion

Photographs taken at sunset with regular daylight film produce a characteristic red-orange distortion. To capture the drama and beauty of the almost horizontal angles of cast shadows at this time of day, sometimes you'll have to accept difficult source material. Until you master the principles of color in light and shadow, you can reduce the red-orange cast with a blue filter. (Photo by Nancy Crase)

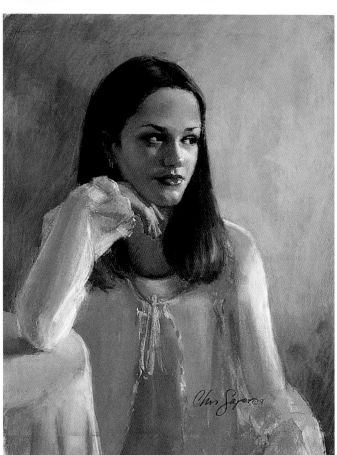

Use Color Distortion to Set a Mood

At times you'll want the red-orange cast of late afternoon sun to permeate your canvas. Bathing your subject in warm light lends a restful, comforting mood to your portrait. This painting is a good example of exploiting rich, warm color in the shadow's core along the length of the nose.

JESSICA
Pastel on Wallis paper
16" x 12" (41cm x 30cm)
Collection of Eileen and
 Preston Long

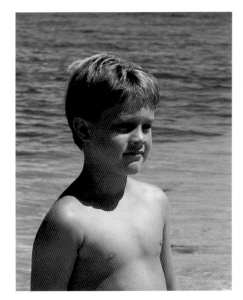

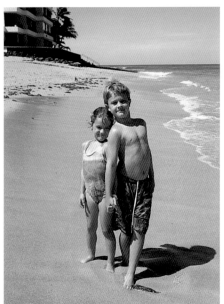

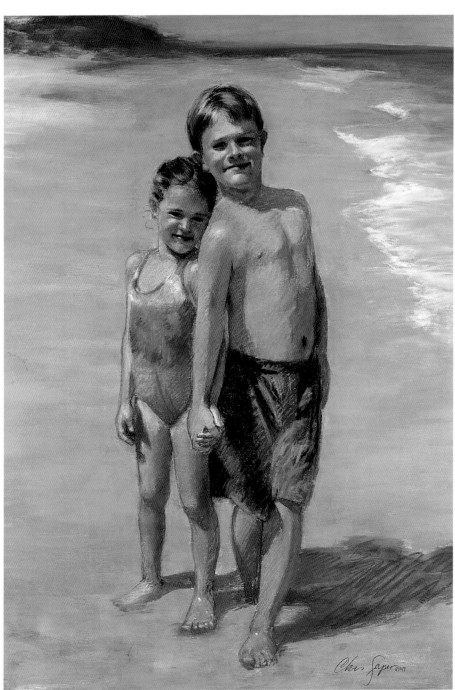

Cast Shadows Tell Time

The two reference photos shown above for *Beach Buddies* (at right) were taken at approximately 11 a.m., just as the sky was reaching its bluest point. The direction of the shadows gives away the time of day, which is most evident in the eye sockets and under the nose. Even in black and white, these photos would tell the time of day. Once you know the time, you can quickly deduce the Kelvin temperature and the colors to use for both light and shadow.

Painting Beach Scenes

Beach scenes are among the most complicated to paint well because they're fraught with so many temperature shifts, reflected colors and reflected lights. The yellow color of direct sunlight drenches the figures and sand, but the blue sky strikes the upward-facing facial planes, slightly cooling the skin color. The ocean mirrors the sky, bouncing blue light up into the shadows. The sand reflects warm light into the shadows on the lower legs. As the shadows move toward the head, the effect of cooler reflected color takes over.

BEACH BUDDIES
Pastel on Wallis paper
36" x 26" (91cm x 66cm)
Collection of the artist

INDIRECT SUNLIGHT

Clear Skies

Color: blue

Temperature: approximately12000K+
Without the direct yellow of the sun's rays to color the objects it touches, there is only the vast blue of the sky to reflect light on them. Subjects lit by cool, indirect sunlight have warm shadows.

Hazy or Cloudy Skies

Color: warm, grayed-down blue or yellow

Temperature: approximately 7500K
Hazy conditions can reduce or eliminate the influence of blue completely, and will result in less temperature variations between light and shadow.

Well-Balanced Warm and Cool Light
Painted from photos taken just before sundown, direct warm light flooded onto the subject from the right. However, cool blue light was also bounced onto her shadow side from the left. Like other design principles of unequal balance, both light temperatures could not be shown equally. Here, the warm light source predominates.

To make this portrait work, the temperatures in the center section of her face straddle the fence—cooler than the warm light, yet warmer than the cool light.

VICTORIA
Pastel on La Carte
 sanded paper
22" x 16" (56cm x 41cm)
Collection of Mr. and Mrs.
 Clifford Crase

ARTIFICIAL LIGHT

Incandescent Household Light

Color: orange
Temperature: approximately 2300–2800K
Similar in color to the natural light at sunrise and sunset, incandescent light falling on a model will create a warm orange cast to the areas of skin and clothing touched by the light. The areas of the face and clothing in shadow will be cooler in temperature.

Fluorescent Light

Color: blue-green to yellow-green to pink
Temperature: varies widely
Often used in offices and commercial settings, fluorescent light falling on a model usually casts a cool blue-green color on the areas of skin and clothing it touches; the shadowed areas are rendered warm. Fluorescent light emits peculiar light waves and is not manufactured to any one specific Kelvin standard.

Halogen Light

Color: yellow-orange
Temperature: approximately 3000K
By using a rheostat with your light standard, you'll be able to vary the color of halogen light. At full brightness, halogen light is yellow-orange. As the light dims, it becomes decidedly orange, then red-orange.

3200 Tungsten Photo Light

Color: yellow-orange
Temperature: 3200K
These bulbs are manufactured to exactly match 3200 tungsten film. While essential for color-controlled photography, they're impractical to use in lighting a model for any length of time. They're expensive, delicate and hot, and emit accurate color for only a limited number of hours.

For a more complete chart of various light sources and their Kelvin temperatures, see Appendix B (page 121).

Mismatched Kelvin Degrees
When lighting and film don't match, it is possible to compensate a bit. Take a look at this reference photo for the painting below. Here, incandescent studio lighting (2800K) was used, along with normal daylight film (5500K). To reduce the color distortion that such a combination would cause, you can use a blue filter or, better yet, tungsten-rated film.

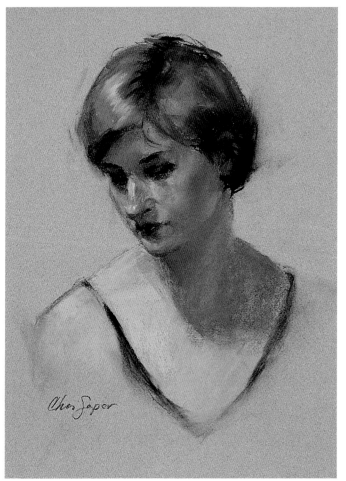

Painted from life, the finished portrait more accurately conveys color, temperature and value. The warmer reflected colors in the shadow of the neck and the cooler reflected colors in the shadowed cheek obey the principles of shadow and stay in their place. The model's nose is the part of her face closest to the light, and its proximity is exploited with warm, saturated color. The section of her hair nearest the light is treated in exactly the same manner.

BETTINA'S CHOICE
Pastel on Canson paper
16" x 12" (41cm x 30cm)
Collection of the artist

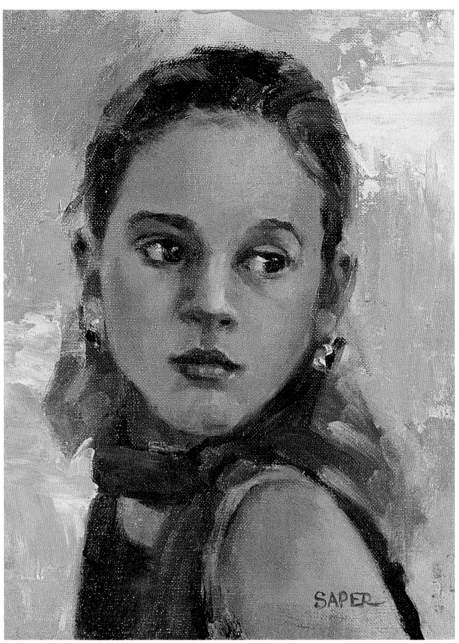

Work in the Right Light

Regardless of the type of light on your subject, it's essential that the light on your canvas is neutral.

Working under *incandescent lights* will lead to skin that is overcompensated with cool colors, such as blue-green, while working under *fluorescent light* will result in skin that appears to be badly sunburned.

To avoid color distortion, either limit your working sessions to natural daylight hours or work under color-corrected lightbulbs. Widely available, color-corrected lightbulbs average about 5000K, closely resembling neutral daylight conditions.

Cool Fluorescent Light

One of the few times you may prefer fluorescent-colored light is when showing a subject in a theatrical- or performance-related context. Otherwise, blue or blue-green skin tones are so powerfully associated with failing health that they're usually undesirable.

The drama of a blue-green light source is appropriate for this small subject waiting to be called onto a large stage. Shadowed areas of the face are warmed with grayed-down reds.

SPRING SHOW
Oil on linen panel
8" x 6" (20cm x 15cm)
Collection of the artist

LIGHTING AND DISTANCE

The proximity of your subject to the light source is an important factor in painting skin color. The closer she is to the light, the stronger the color of the light on her face. For example, when a model faces an incandescent light, her nose is a tiny bit closer to the light than her cheek. If you emphasize color shifts when you paint, you'll add energy and dimension to your portrait.

HIGHLIGHTS NEED COLOR, TOO

The very last things to paint on the top of your surface are the highlights reflecting the light source itself. The most effective device to convey the strength and intensity of the brightest light on a face is to change its temperature. Warm light sources produce cool highlights, while cool light sources yield warm highlights.

Highlights are not dashes of bravado. They have a location, shape and color. If you don't see a highlight, don't paint one. It's better to understate than overstate a highlight.

Roving Highlights

Highlights on a model will move with the position of the viewer. When you paint from life, be sure to place the highlights based on where you see them from your position at the easel. When a group of artists are painting from a single model, each painting should show the highlights in slightly different places.

Try this: Move around the model, from her far right to far left. Observe how the highlights continually move. If you move far enough around, they may disappear altogether and new ones may appear elsewhere. Contrast this apparent movement to a cast shadow. Cast shadows stay put, even if you change your viewing position.

If you work from photographs, highlights will remain forever frozen by the camera's eye.

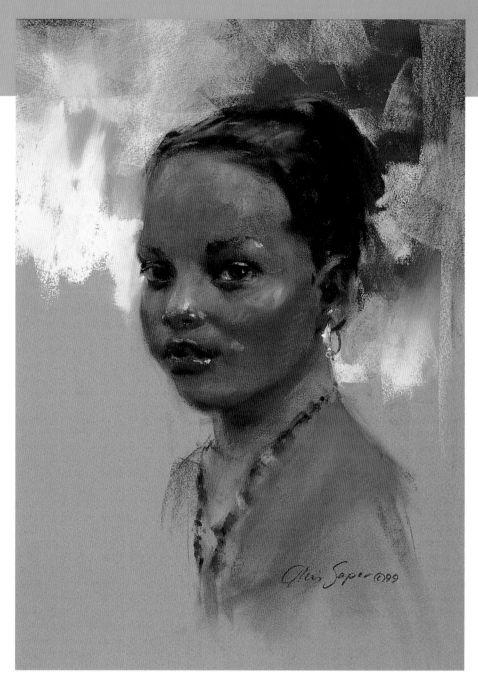

Using Highlights

Highlights can tell temperature, too. Here, warm sunlight adds rich color to the upward-facing plane, while slightly cooler shadows are reduced in intensity. Very light blue-green highlights are carefully placed, mirroring the clear blue Jamaican skies of my subject's home.

ANGELIE
Pastel on Canson paper
16" x 12" (41cm x 30cm)
Collection of the artist

The End of Guesswork: The Color and Temperature of Shadow

Once you've made a decision about the color of light, it's easy to decide on the color of shadow. The color of skin in shadow is always made by comparing it to the color of skin in light.

THE THREE PRINCIPLES OF SHADOW

As you determine the color you want for the shadowed areas of your subject's face, keep the following three principles of shadow in mind. First, *avoid using strong color in shadows*. Shadows should be lower in intensity and use grayed-down hues. Second, *avoid hard edges in shadows*. Keep these edges softer than the edges in light. Finally, *avoid strong contrast in shadows*. Make the range of values in the shadowed areas of the face narrower than in the light areas of the face.

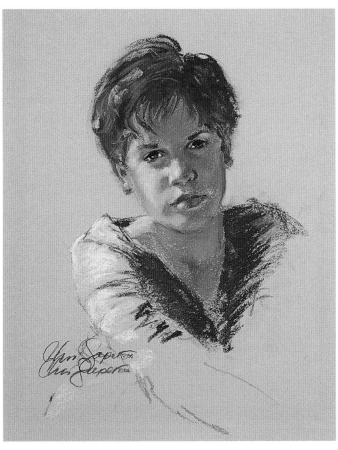

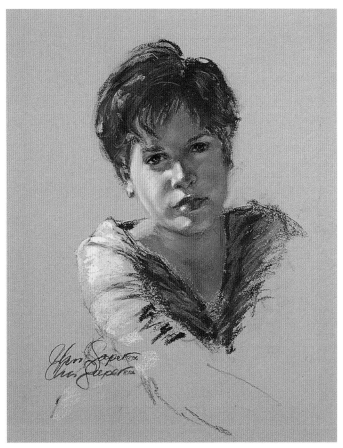

Problem

This portrait contains every imaginable shadow problem. Not only is the shadow color too saturated, but it's also the incorrect temperature—it's every bit as hot as the direct yellow sunlight illuminating the model's face. Even though both of the model's eyes are in shadow, they contain too much sharp-edged detail. The whites of her eyes are also too light, accentuating the edge problems. Finally, a lack of value differentiation in the light areas draws unwanted attention to the shadowed side.

Solution

Correct the color temperature in the shadows by adding greens, blues and violets without changing values. This will provide immediate relief. Next, the flick of a finger should be enough to soften the edges and reduce contrast in the eyes. Lighter values in the light areas will return interest to where it belongs. Simply add highlights on the nose and lip with a very light blue-green and violet, which are opposite in temperature to the warm sunlight. Although the changes are subtle, the effect is not.

CHRISTINA
Pastel on Canson paper
16" x 12" (41cm x 30cm)
Collection of the Roger Mueller Family

THE COLOR OF SHADOWS

Shadow color is determined by four elements: *local color, color of the light source* (opposite in temperature), *darkness of the shadow* and *direction of the facial planes.*

The *local color* of human skin is always some variation of orange (see Chapter Three). In warm light, skin color becomes both more saturated and warmer in color. In shadow, it becomes both less saturated and cooler. To reduce the saturation, gray down the local skin color with its complement. Since a color's complement is also opposite in temperature, you will have begun to move the temperature of the skin in shadow in the right direction.

In cool light, the skin's orange color is slightly grayed down by the bluer light. To stay in the light, however, the cool tones must retain some intensity, remaining clean and identifiable. The shadowed areas of the skin lit by a cool light will become even warmer in temperature than the local skin color. To keep the shadowed areas from leaping out, they must be lower in saturation than colors in the light.

The local colors of other elements in your painting, such as clothing and background, change in light and shadow in exactly the same way as skin color.

As the subject moves closer to the *light source*, two significant things occur. First, there is an increased change in value between the areas in light and shadow. Second, the edges of the cast shadows become harder and darker, with the darkest, sharpest edge right next to the object casting the shadow, such as the nose. Alter the hardness of your portrait's cast shadows, even when they occur in places as small as the upper lip.

Facial planes that face upward are generally cooler than ones facing downward. In

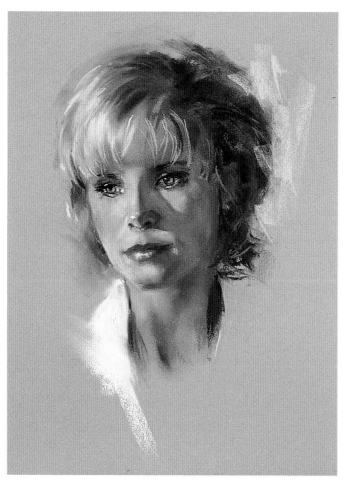

Shadows Create Sharp Edges
Shadows created by a light source close to the model render sharp edges along shadows cast by the nose, both on the cheek and upper lip.

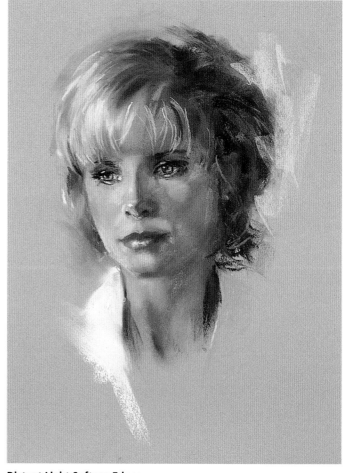

Distant Light Softens Edges
Moving the light farther away softens the edges of cast shadows and slightly reduces the contrast between light and shadow.

most portraits, upward-facing facial planes include the top of the forehead, the brow ridge, the bridge of the nose, the upper section of the cheek, the lower lip and the upper section of the ball of the chin.

In natural daylight conditions, upward-facing planes reflect some of the blue of the sky, while downward-facing planes reflect the warmth of the earth or grass, or other parts of the studio's interior. Like every other guideline presented in this book, there are always exceptions. It's your job to find the differences and apply sound portrait painting principles to each new situation.

Two Paintings in One: Dark and Light

"I encourage my students to think of their paintings as consisting of two paintings: the light painting and the dark painting," explains master pastellist Sally Strand. "Neither one may borrow values from the other." In other words, the lightest value in shadow, to stay in shadow, must remain darker than everything in light. Likewise, the darkest value in light must remain lighter than everything in shadow.

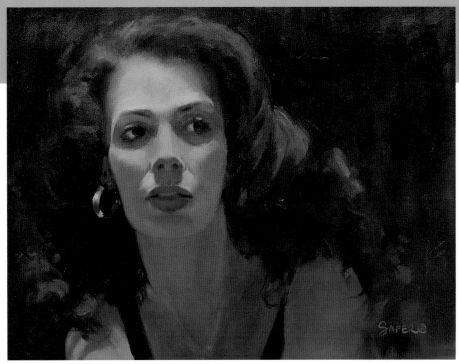

Skylights Capture the Beauty of Blue Daylight
Place your subject under a skylight to isolate the reflected temperature of the blue sky and eliminate the influence of the yellow sun. Exploit the coolness in upward-facing planes. This lighting was a natural choice to showcase the exquisite structure of this model's face and to depict the beauty of her Puerto Rican heritage.

SOLITARY SONATA
Oil on canvas, 14" x 18"
(36cm x 46cm)
Collection of the Lieb
Family

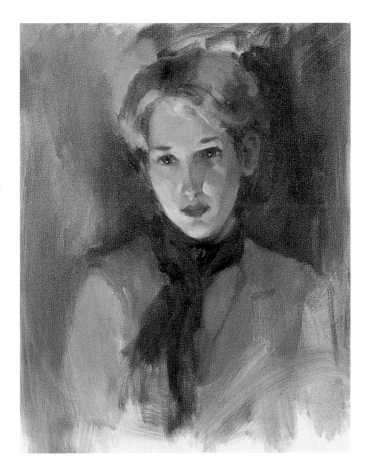

Use Uplighting to Lend Drama and Mood
Varying the direction of the light source is an excellent exercise because it forces you to examine unexpected shapes and values.

Warm, incandescent uplighting can create the impression of candlelight, firelight or simply an intimate reading light. In the piece at right, the area near the model's mouth is the area of skin closest to the warm light source. Consequently, it's the area of the face painted with the greatest color saturation and warmth.

PRIVATE THOUGHTS
Chris Saper with Phil Beck
Oil on canvas
20" x 16" (51cm x 41cm)
Private collection

The Edges of Shadows

The edge that is created where the form turns and light meets shadow is called the core of the shadow. Closest to the viewer, the shadow's core has three important characteristics. The shadow's core is darker in value than the rest of the form shadow. It is also warmer in temperature than either the light or the shadow, and has greater color intensity than the areas on either side of it.

An Undefined Shadow's Core
The shadow's core is created where the length of the nose moves from shadow to light. Although accurately drawn, the form is flat and uninteresting.

A Core With Drama
Adding only a darker color with more saturation and warmth to the core will turn the form, creating dimension and interest.

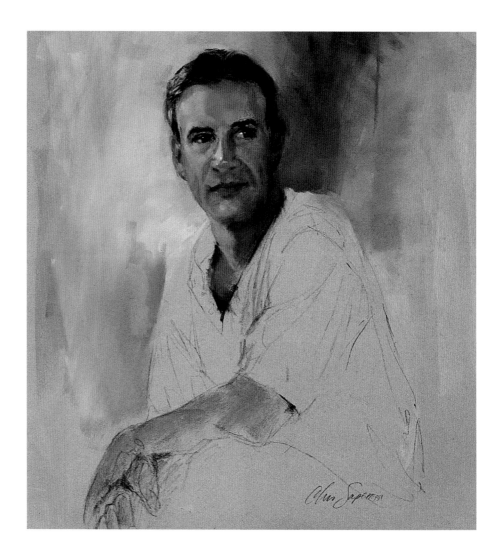

Create a Strong Character
The use of strong color and warm temperature (downright hot in places) throughout the cores of form shadows can punctuate a model's strong character or personality.

RON
Pastel on La Carte sanded paper
22" x 16" (56cm x 41cm)
Collection of the artist

SHADOWS AND REFLECTED COLOR

Last, but definitely not least, the color of skin in shadow (and, to a lesser extent, in light) is influenced by the nearby colors of clothing, other skin and the background.

A model's shirt is the article of clothing closest to the face, adjacent to the downward-facing planes of the chin and throat and, to a lesser degree, the underside of the nose. Fabric usually acts as a mirror, bouncing color up into nearby planes. Smooth, shiny fabric, such as satin, reflects more color (and light) than fuzzy fabric, such as terry cloth or wool. Be aware of the different influences of color when you help your subject select clothing.

When clothing is neutral, or the model is wearing a top with a lower-cut neckline, the underside of the model's chin and nose usually reflect the color of the skin of her neck and chest. In this case, reflected light contains more of the model's own skin color, as influenced by the temperature of the light source.

When the light source is warm, warmer skin color is reflected into the shadow; when the light source is cool, cooler skin color is reflected into the shadow.

Background color has less influence on skin color, since its color is primarily reflected onto the model's back. To create beautiful color unity, it's important to integrate the background colors into other areas. Add a touch of background color to the turning-away planes of the face in order to add a sense of depth and harmony. Look for areas in the hair and clothing to add some background color as well.

Reflected color represents a wonderful opportunity to exploit the beauty of skin color. Remember to observe the three principles of shadow by avoiding intense colors, hard edges and contrasting values.

Arbitrary Color: A Fatal Flaw

Make a decision about your portrait's color harmony before you pick up your brush. Faithfully painting the skin color by what is observed and then arbitrarily changing the color of clothing or background is nearly impossible to do believably, even if you're willing to repaint the entire canvas to accommodate a midcourse color change.

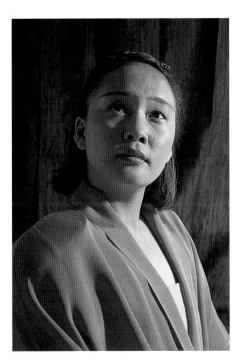
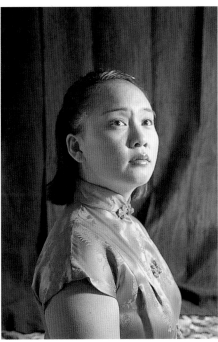

The Impact of Adjacent Color

Help your subject choose clothing colors that work well with your overall color harmony. Remember that clothing will reflect color and light, and be true to it throughout your portrait. If you don't like the color, ask your model to choose something else to wear.

SHADOWS AND REFLECTED LIGHT

Reflected light is an important aspect of painting skin (and everything else) in shadow. Where two objects touch in shadow, there is a slight ping-pong effect of light bouncing back and forth.

This effect causes a slight change in both color and value, making the area of reflected light a tiny amount lighter than the rest of the shadow. Because reflected light is so fun to find and exciting to paint, it's easy to overstate the change in value. Easy does it! Remember that reflected light is still part of the shadow, and to stay there, it must follow the three shadow principles.

Too little reflected light

Too much reflected light

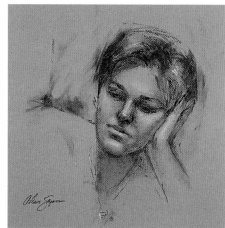

Just right

Use Reflected Light Sparingly

Areas where forms touch (above, between the palm and cheek) are flat and dead without reflected light. The beauty of reflected light, however, can be seductive, and it's important to guard against overdoing it. Keep your shadow areas in their place by controlling the value shift in the reflected light. It's invariably darker than you first think. The image on the left contains too little reflected light, while the image in the center contains too much. Notice the difference between these two images and the one on the right, which has the correct amount of reflected light.

Color Harmony for the Portrait Painter

Choosing a color harmony for your portrait is one of the necessary early decisions to make. Changing the color scheme partway through the portrait means having to repaint the entire surface. Here we will focus on two color harmonies. Both work extremely well for portraits and are easily adapted to many situations. Of course, there are other color harmonies available, too, and their use is the subject of a number of excellent books on the market (see Appendix A on page 120).

ANALOGOUS COLOR HARMONY FOR PORTRAITS

Classic *analogous color schemes* include adjacent wedges of color on the color wheel, including their grayed-down neutrals and lighter and darker versions of the colors themselves.

Think of the color wheel as being like the face of a clock. It's easiest to remember that a "wedge" represents the approximate area between any two hours on the clock. The *analogous color wheel* has tremendous beauty in its simplicity: Simply fill in the dominant color you plan to use, and the wedge-shaped window shows you what colors to mix or, in the case of pastel, to select. If you don't see it, don't use it.

However, conventional analogous color harmony needs to be adapted for portrait use, since, as you'll note in Chapter Three, all skin contains some element of orange. A true analogous color scheme for portraits would limit the wedges available to those containing some element of red and yellow. In order to adapt it for use with a portrait, be aware that orange will be used in addi-

tion to whatever analogous color wedge you like. As long as your entire painting—subject and background alike—follows the color rules governed by the light temperature, your portrait will have beautiful harmonious color. The color of light unifies everything else.

Discords are exactly what they sound like: bits of color that are out of harmony with the rest of the color scheme. The analogous color wheel has small circular openings at about five o'clock and seven o'clock (where the dominant color always shows at twelve o'clock) showing two discords. Used in small quantities, discords add energy and capture the eye, so place them near your center of interest to support your focal point.

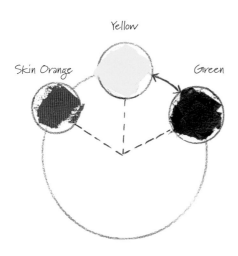

Yellow-Green Analogous Color Harmony

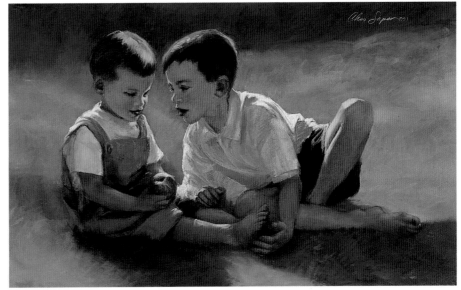

JIMMY & JAKE
Pastel on Wallis paper
22" x 34" (56cm x 86cm)
Collection of Mr. and Mrs. James Hoselton

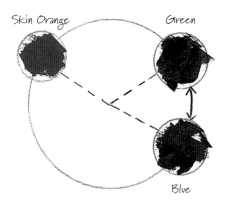

Blue-Green Analogous Color Harmony

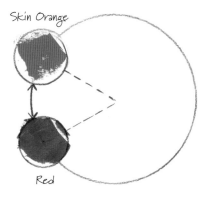

Red-Orange Analogous Color Harmony

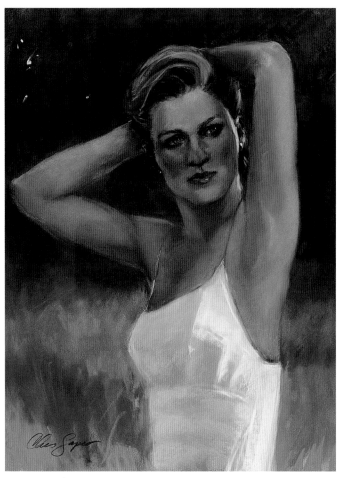

A MOMENT'S PAUSE
Pastel on La Carte sanded paper
22" x 16" (56cm x 41cm)
Collection of Ms. Victoria Gordon

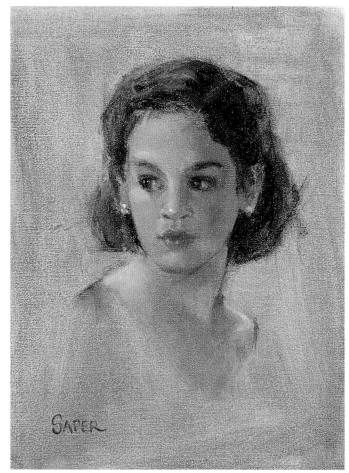

THE FAERIE TALE
Oil on linen
12" x 9" (30cm x 23cm)
Collection of the artist

COMPLEMENTARY COLOR HARMONY

Perhaps the most versatile for portrait use, the *complementary color scheme* is beautifully suited to your oil and watercolor palettes, which are based upon accurate complements. Since all skin color has some aspects of red and yellow in it, you can easily adapt to a red-green, yellow-violet or blue-orange scheme. Keep in mind the principle of unequal balance. One of the complements in the portrait must be dominant, and the other subordinate.

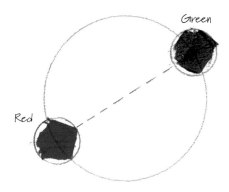

Red-Green Complementary Color Harmony

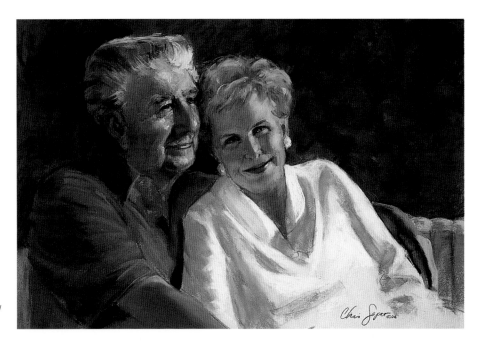

DUFFY'S FOLKS
Pastel on Wallis paper
18" x 24" (46cm x 61cm)
Collection of Pat and Duffy
McMahon

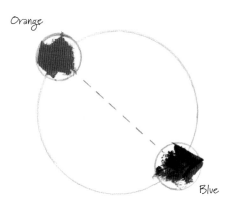

Blue-Orange Complementary Color Harmony

REID & ERNIE
Pastel on La Carte
sanded paper
18" x 26" (46cm x 66cm)
Collection of G. Price

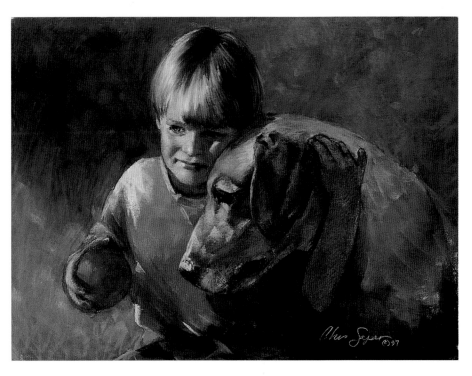

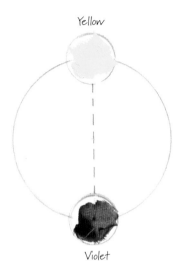

Yellow

Violet

**Yellow-Violet Complementary Color
Harmony**

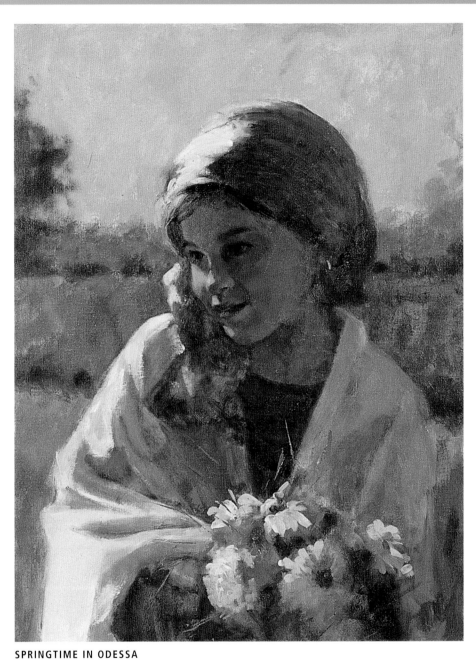

SPRINGTIME IN ODESSA
Oil on linen
18" x 14" (46cm x 36cm)
Private collection

Palette Selection and Key Considerations

The best general rule in selecting a working palette is to simplify. Use the fewest number of colors to get the job done. A limited palette promotes color harmony that is easy to get, easy to keep and easy to duplicate.

SETTING UP YOUR MIXING PALETTE

Many painters arrange colors the way they appear on the color wheel. Actually, the arrangement doesn't matter as long as you do it the same every time. Become so familiar with their location that you'll automatically reach for the right color on your palette.

Placing a middle-value gray paper under your glass or Plexiglas mixing palette will help you judge the value of the color you're mixing. You'll be able to more easily relate the mixed color to what's already on your canvas.

THE KEY TO CLEAN, FRESH COLOR

Beautiful clean colors result from mixing hues of the right temperature. To mix great secondary or tertiary colors, together they must contain only two of the three primaries. The moment a third primary is introduced, you'll be on your way to mixing some version of mud.

Carefully consider the temperature of each color on your palette. For example, you have three reds, each of a different temperature: Cadmium Scarlet is warm (it contains some yellow), Permanent Rose is neutral and Alizarin Crimson is cool (it contains some blue).

Beautiful violets will result from mixing Ultramarine Blue with either Permanent Rose or Alizarin Crimson because none of the colors have any yellow in them. However, mixing Ultramarine Blue with Cadmium Scarlet will result in brown because the third primary, yellow, is contained in the scarlet.

NOTES ON BLACK AND WHITE

Both black and white can be used to lighten or darken other colors; however, they will both cool the color they're mixed into. Check the resulting temperature of every color to which you add either black or white. You may need to adjust the temperature.

Neither black nor white should ever be used to paint objects that are black or white. Rather, mix your own black from colors on your palette, while your whites should reflect the color of the light.

Make Your Own Black

Never use tube black to paint something that is black! Only use tube black for the subtle and very beautiful cooling quality it has when added in tiny quantities to other colors on your palette. Using tube black to paint something black will render the object dull, flat and out of harmony with the rest of the surface. It will forever remain a rough spot and will distract the viewer. Black may also be used to darken colors, but be aware that they'll also be cooled. You may need to add another warmer color to correct the temperature.

To paint an object that is black, try mixing your own black. For oils, equal parts of Alizarin Crimson and Phthalo Green will do it every time. For watercolors, mix Alizarin Crimson and Winsor Green (Blue Shade) or Viridian.

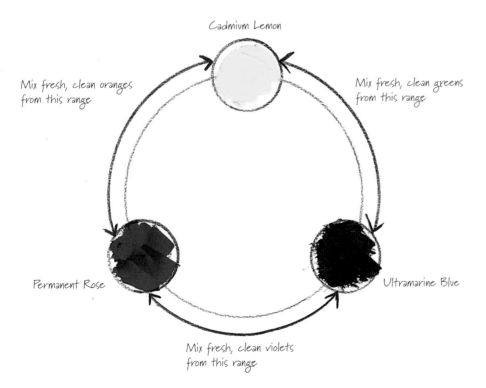

Cadmium Lemon

Mix fresh, clean oranges from this range

Mix fresh, clean greens from this range

Permanent Rose

Ultramarine Blue

Mix fresh, clean violets from this range

Pay Attention to Temperature When Mixing Colors

You can always be sure that your mixed colors will stay fresh and clean by selecting them from within the same temperature range.

Think of any two of the primaries on your palette as "temperature bookends." Mix any two colors inside the bookends to ensure clean color. Selecting a color from outside the bookends creates a muddy color because it introduces the third primary.

OIL

My oil palette for portraits is based upon Stephen Quiller's color research, beginning with tube colors that are accurate complements. Starting out right will simplify the creation of beautiful complementary grays and luminous neutrals, and deliver visual harmony to your viewer.

All of the oil paintings in this book were painted with Winsor & Newton and Utrecht colors. (I also use Terre Verte by Rembrandt, but only in the preliminary drawing or grisaille phase.) Use whatever paints you prefer, but keep in mind that color and other qualities will vary from brand to brand. I use the following colors:

Cadmium Lemon (W&N)
Cadmium Scarlet (W&N)
Permanent Rose (W&N)
Ultramarine Violet (W&N)
Alizarin Crimson (U)
Ultramarine Blue (U)
Titanium White (U)
Ivory Black (U)
Phthalo Green or Viridian (both U; Phthalo is a strong staining color, so Viridian might be easier for beginners to control)

WATERCOLOR

Choose watercolors the same way you choose oil: select accurate tube complements.

There are hundreds of colors in the watercolor marketplace: staining, nonstaining, transparent and opaque. Focus on transparent, nonstaining pigments to simplify your portrait painting.

To keep skin tones beautiful and translucent, keep your brushes clean and change your water twice as often as you think you should.

I used Winsor & Newton watercolors for the paintings in this book. Again, use whatever paints you prefer. I used this basic palette:

Alizarin Crimson
Aureolin
Rose Madder Genuine
Cobalt Blue
Viridian
Raw Sienna
Burnt Sienna

PASTEL

Because pastels can't be mixed like oil or watercolor, you will need an inventory (as opposed to a standard palette) of sticks. Your inventory should include a full range of color and value and will be limited only by your budget. To get started, buy a standard "portrait" set of soft pastels (*not* oil pastels) of about forty-eight sticks, plus a set of darks. Most manufacturers now offer sets of twelve to eighteen darks—you'll need them.

Begin each new portrait with a freshly selected palette of sticks. Bearing in mind

Make One Color Your Star

Swedish painter Anders Zorn (1860-1920) is known for his limited four-color palette. Nearly all of his paintings show all three primary colors, but two of them are always greatly diminished in intensity, allowing the third to shine as the star of the painting. Zorn chose red to star in most of his paintings. Any color can be your star, but it can't shine unless the other colors are subordinate.

Here, with the exception of red, every other color in this portrait is grayed down to some degree. Although covering only a tiny amount of surface area, this strong, clear note of red is beautifully balanced with the darker, grayed-down green of the paper, which represents a much larger surface area.

the color harmony you've selected, choose several sticks at the dark end of the value range, several in the middle and one to represent the lightest value in the portrait. Always begin with the fewest number of pastels necessary. Add sticks to your working palette only as you use them, not because you might use them.

As a general guideline, use darker sticks first because it's far easier to use light pastel over dark than to use dark pastel over light.

Once you've used a stick of pastel on your painting, separate it from your larger pastel inventory by placing it on a clean white towel. Wipe each stick on a clean part of the towel before each stroke to keep colors fresh and clean.

Select sticks that are similar to not only the tube oil colors previously described, but to the oil colors once they're mixed. Why? Once those little wrappers are gone, your only hope of describing and finding a piece of pastel is by its hue, value and intensity.

THE CEREMONY
Pastel on Sabretooth
16" x 12" (41cm x 31cm)
Collection of the artist

Less Is More

Using a limited, analogous palette of pastels, this painting was completed with less than a dozen sticks. The complementary green paper works beautifully with the warmth of the subject's skin.

MY UNCLE MURRAY
Pastel on Canson paper
16" x 12" (41cm x 30cm)
Collection of Jeffrey and Vivian Saper

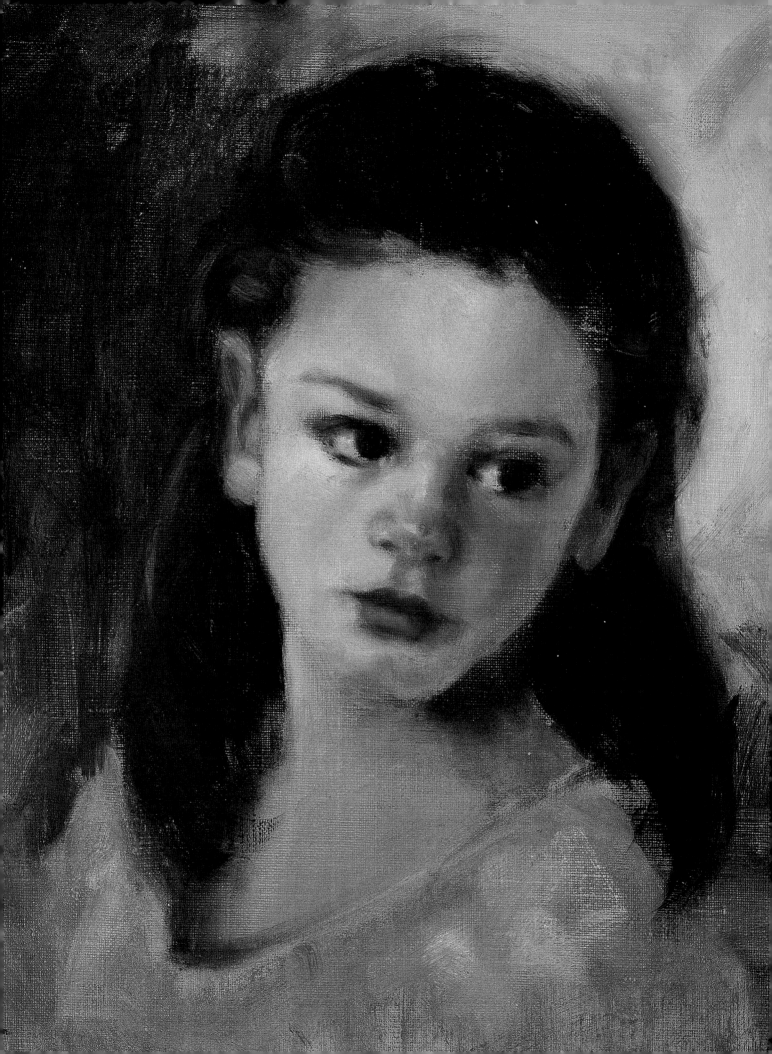

3 THE LOCAL COLOR OF SKIN: A QUESTION OF ORANGE

The portrait painter is faced with a breadth of color and value in human skin that can at first seem elusive and overwhelming. It is not. There are far more similarities than there are differences in painting human skin, even among different ethnic or racial groups.

There are two significant components to skin color. Understanding what they are gives the artist a simplified and direct way to determine, and paint, the local color of skin. And once the painter knows the local color of the subject's skin, it's a simple matter to modify it based on the color of the light source.

THE ARTIST'S CHILD
Oil on linen
12" x 12" (30cm x 30cm)
Collection of the artist

The Determinants of Skin Color

The two significant factors that comprise skin color are the amount of pigment an individual has and the extent to which the underlying blood supply can be seen through the skin.

By far, the most significant component is the amount of the pigment *melanin* in a person's skin. That amount of melanin is genetically determined and can be dramatically increased by exposure to the sun.

Melanin only comes in one color: brown-black. So there are not different colors of pigment, only different amounts. People who produce more melanin have darker skin, and those with less melanin have lighter skin. Sun exposure causes a temporary increase in the amount of pigment a person produces. Some skin does not produce melanin readily, evidenced in many fair-complected individuals who always get a sunburn and never get a tan. The more melanin in a person's skin, the less translucent it is.

Melanin is the same throughout our bodies. Even eye color is the result of the quantity of brown-black melanin in a person's iris. Dark brown eyes have a lot of melanin; hazel or green eyes have less. As the amount of melanin all but disappears, eyes become lighter and lighter blue. Hair color follows the same coloration principle, from black to brown to red to blonde, and finally to white.

The second major factor in skin color is the blood supply under the skin. Just below the surface, oxygen-rich capillaries supply the red in skin color. Areas of the body with greater blood supply are redder, as are areas where the forms are smaller, including the nose, lips, ears and fingers.

The blood in veins, however, is bluer, having given up its oxygen to the tissues of the body. Venous blood has a powerful cooling effect on skin color, supplying the blue, blue-violet and green in skin, which modifies other warmer colors. The more translucent a person's skin, the more its color is influenced by blood supply.

Translucency also affects the color of the white of the eye. The bluish cast in the whites of children's eyes becomes more yellow with age, caused by the thickening of the white of the eye.

THE PAINTER'S PERCEPTION OF SKIN COLOR

The color of all human skin, from the artist's standpoint, is some variation of orange. That is, it contains aspects of red and yellow in differing proportions. The orange of skin exists in an enormous range of values, from light (as seen in the fairest-skinned redheads or near-albino blondes) to dark (as seen in equatorial Africans and some Eastern Indian groups).

The orange of skin also exists in a wide range of color saturation, as it is grayed down with greens (such as olive-skinned Mediterranean groups) or blues (such as the Burnt Sienna hues of some African and Native American groups).

Like color, human skin tones can be described in terms of value, color and saturation.

Determining the color of your subject's skin is straightforward. Answer these three questions: (1) *What kind of orange is the skin color?* Is it a little to the red side, a little to the yellow side or right in the middle? (2) *What value is the skin color?* Light, medium or dark? (3) *How saturated or grayed down is the skin color?* Is it grayed with blues (cooler) or greens (warmer)?

In this section, color and palette descriptions will relate to the local color of skin before it is altered by the color of the light falling upon it. Most basic skin color mixtures have a red, yellow, white and neutralizing color.

KEY POINTS TO PAINTING SKIN IN SHADOW

Shadow color cannot be determined without first identifying the color of the light. Use the same color-value-saturation checklist to identify shadow color, but keep in mind that skin in shadow is not a darker version of skin in light—it's a different color. First, *shadow color is less saturated than light color.* Add the complement of the local color to reduce saturation. Second, *shadow color is affected by the color of the light source.* Add the complement color of the light source, which will also produce a temperature shift. And third, *shadow values are determined by the strength and proximity of the light source.* Diffused, distant light produces only slight value differences between light and shadow. Closer or stronger illumination increases the difference in values.

See Appendix C (pages 122-125) for sample color charts for each skin group, illustrating how skin color changes in light and shadow, depending on the temperature of the light source.

Conveying Ethnicity

Skin color alone is rarely enough to convey a person's ethnicity. For every generalization, there are many readily observable exceptions. For example, there are some Whites with skin tones darker than those of some Blacks, while some Asian skin tones are both lighter and darker than some White skin tones. Also, some Hispanic skin tones are identical in color, value and saturation to some Whites and Blacks.

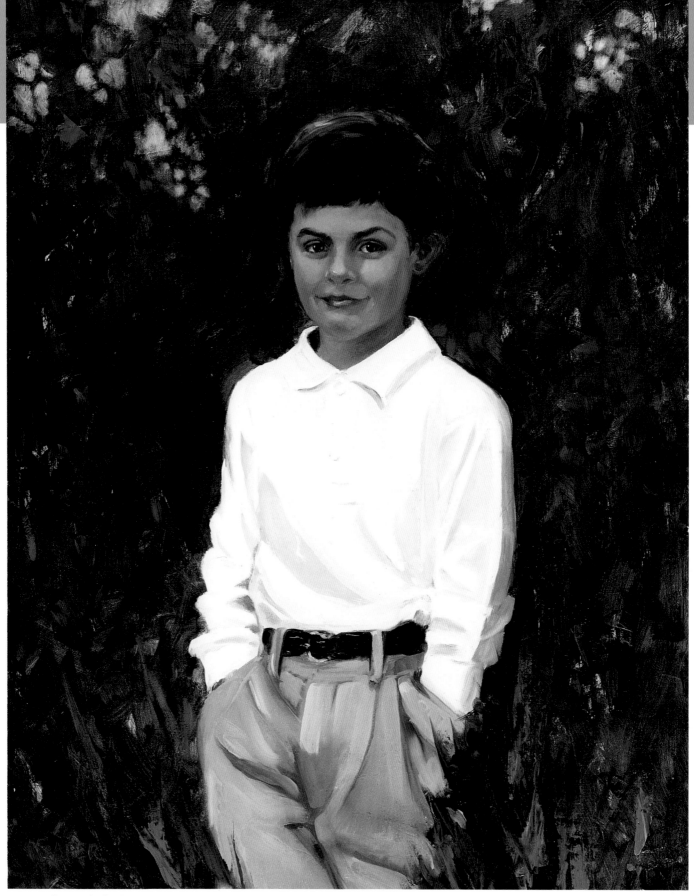

Capture the Strength of Hispanic Heritage

This model's Hispanic ancestry is conveyed as much by his dark lustrous hair and eyes as by his skin color. The upward-facing planes of his face reflect only the cool light of the sky, while the downward-facing planes convey warmth. His skin is a middle-light red-orange, slightly grayed down with yellow-green. The indirect light keeps the skin in light and shadow close in value.

PORTRAIT OF DIEGO
Oil on canvas
30" x 24" (76cm x 61cm)
Private collection

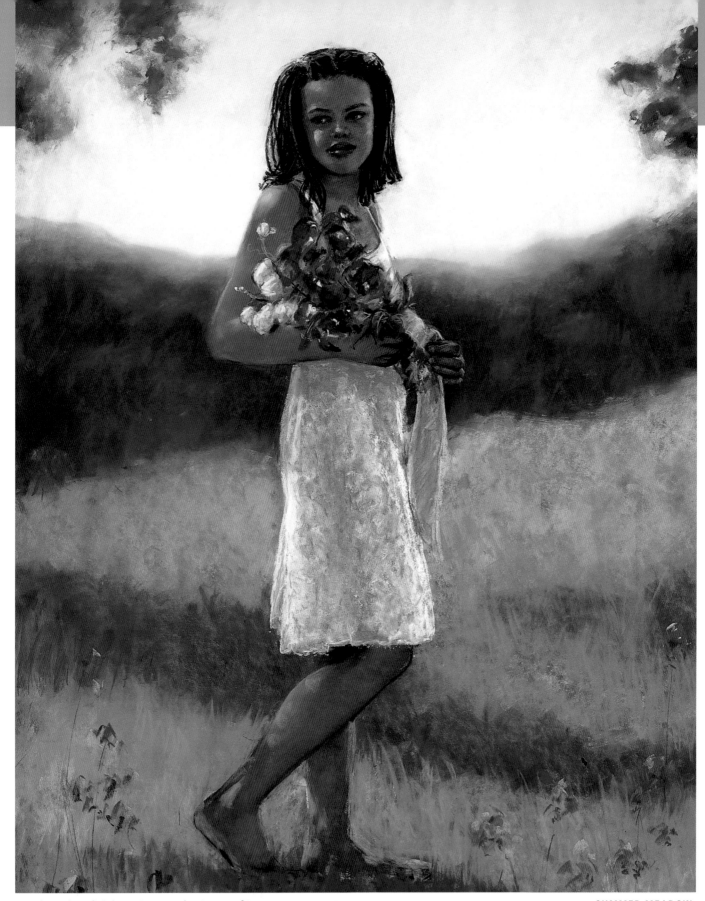

Use the Color of Light to Support the Center of Interest

The subject's dark eyes and hair, in both color and texture, are strong visual clues to convey her African-American influence. Her skin is a middle-dark value grayed down with blues and greens. Warm, direct sunlight from the left strikes her face, providing opportunities to exploit edges and color shifts in both core and form shadows, while a bluer, subordinate light source from the right slightly cools the skin.

SUMMER MEADOW
Pastel on Wallis paper
44" x 32" (112cm x 81cm)
Private collection

Painting Different Skin Color Groups

It is impossible to provide a specific recipe for the skin color of different population groups, since there is such an enormous range of variation within each group. Perhaps the most significant point to remember is that skin color alone is rarely enough for the painter to use to convey a person's ethnicity. Rather than attempting to follow a formula, invest your time and energy in observing each individual. With every new painting, consider the questions of color, value and saturation, and look for visual clues.

While well-painted skin color is extremely important, it must be coupled with other key visual clues in order to show someone's heritage. These important clues include:

- Hair color, distribution and texture
- Distribution of "color bands" across the upper, middle and lower sections of the face
- Shape and placement of the features

The following sections describe how you can incorporate the entire composite of visual information into your portrait to say what you want about your subject. For the purposes of convenience, discussion in this book is limited to four skin color groups: Caucasian, Asian, Black/African American and Hispanic.

The following color charts are in oil using my standard palette. Use the medium of your choice to replicate the colors you see.

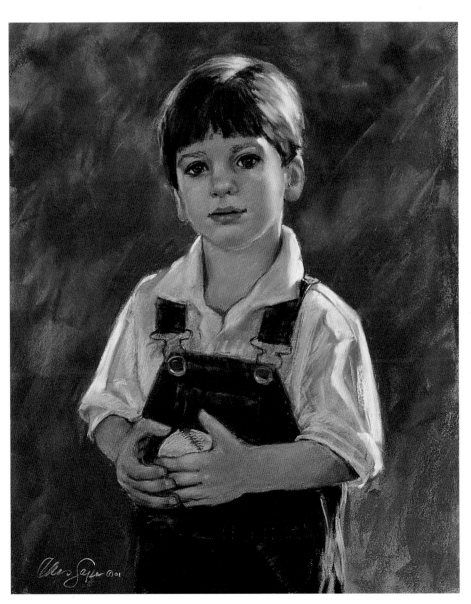

Integrate Your Skin Tones With Background Color

Warm sunlight and cool shadows provide an opportunity to emphasize cool reds and a variety of greens in the areas of skin in shadow. Unify your subject and the background by including background colors in the subject, particularly in the turning-away planes of the face.

DANNY
Pastel on La Carte sanded paper
24" x 13" (61cm x 33cm)
Collection of the Richardson Family

CAUCASIAN

Of the four groups, Caucasians represent the greatest range in skin color and value. The range is further extended because of the varieties of hair color and texture that are represented.

Among the most important differences between Caucasians and other groups are the pronounced color bands that divide the face in thirds. The center band adds red to the ears, cheeks and nose. The upper band colors the forehead with relatively more yellow, and the lower band, in females and children, is in between. In adult males, the beard lends a distinctly blue influence to the lower chin band.

Redheads

- **Skin.** While there is a slight range of value in redheads' skin color, it's generally light to middle-light (as shown in the bar graph to the right). It contains less melanin, so it's also relatively more translucent, giving you wonderful opportunities to incorporate the light blues, violets and greens that lie beneath the skin. The orange in redheads' skin can be either to the red or yellow side. Sun exposure and freckling are strong influences on redheads' skin color.
- **Hair.** Red hair actually ranges in value from middle-dark to light (again, in the bar graph at right), and in color from a dark red-orange, grayed down with blue (commonly called *deep auburn*) to a light yellow-orange (commonly called *strawberry blond*). Its texture runs the gamut from extremely curly/coarse to straight/fine.

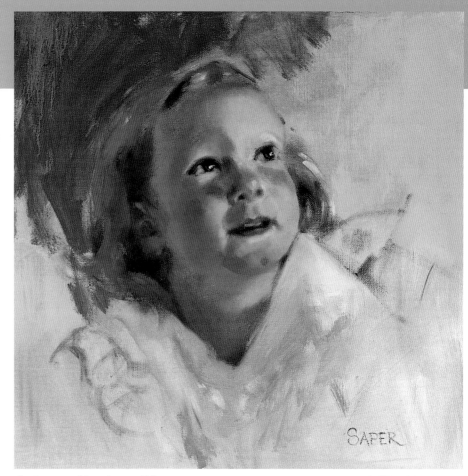

The Beauty of Translucent Skin

Unaltered by the sun, a redheaded baby's fair skin is beautifully showcased in cool blue light. Conversely, the local color of her skin is warmed in shadow, accentuated by the rich color in the shadow's core. This child's skin is a light yellow-orange, grayed down with greens and violets. The light source provides an average change in value between light and shadow. Lost edges in her hair support the center of interest, the expression of wonderment on her face.

ANGEL TIP
Oil on linen
12" x 12" (30cm x 30cm)
Collection of the artist

The Value Range of Skin

The Value Range of Hair

Sample Palette for Redheads: Yellow-Orange

Cadmium Lemon + Permanent Rose + Titanium White

Cooled and grayed down with Titanium White + Phthalo Green

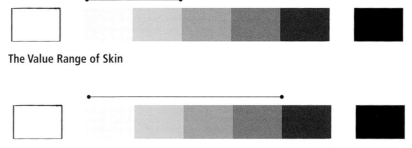

Brunettes

- **Skin.** In general, the easy-to-tan brunette skin contains more melanin and is more subject to changing value and color with sun exposure. In value, brunette skin can be as light as redheads' skin or as dark as that of some Black skin. On the average, it will fall into the middle to middle-light value range. The orange in brunettes' skin is generally a middle orange, or slightly to the red side.

- **Hair.** Brunette hair falls into the range of middle to very dark values, and in color from brown/black to light brown, with either yellow or red influences, often grayed down with green. In texture, it covers the continuum of curly/coarse to straight/fine.

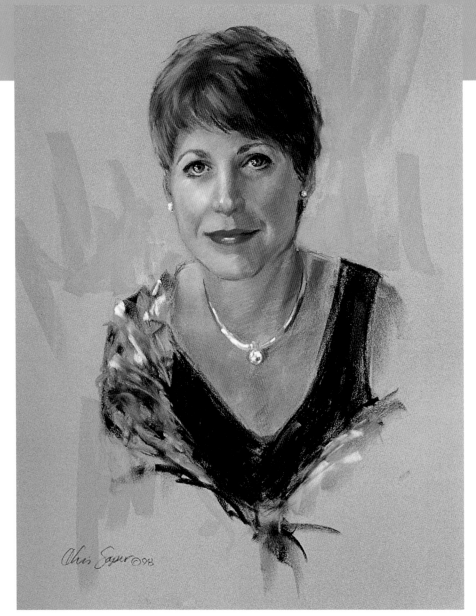

Use Background Color to Reinforce Olive Skin Tones

As a blue-eyed brunette, this model's skin is a middle-light orange, grayed down with green as the neutralizing color. Adding green to the background, hair and shawl reinforces the olive tones in her skin. The overall effect strengthens the blue in her eyes. Diffuse light reduces the difference in value between light and shadow.

BARBARA
Pastel on La Carte sanded
 paper
20" x 16" (51cm x 41cm)
Private collection

Cadmium Scarlet +
Cadmium Lemon +
Permanent Rose

Grayed down with
Titanium White +
Phthalo Green

Sample Palette for Brunettes: Orange

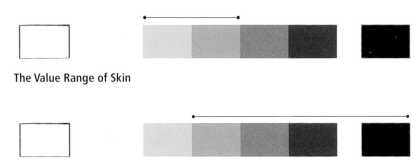

The Value Range of Skin

The Value Range of Hair

Blondes

- **Skin.** Skin color in blondes ranges from light to middle in value. The color range is somewhat broad and can include easy-to-tan orange, red-orange, olive or light-yellow oranges, similar to the fairest of redheads.

- **Hair.** Blonde hair ranges from light brown with a yellow component to very light—almost white—warm or cool yellows. Almost all blonde hair contains some amount of green. Blonde hair comes in a full range of textures.

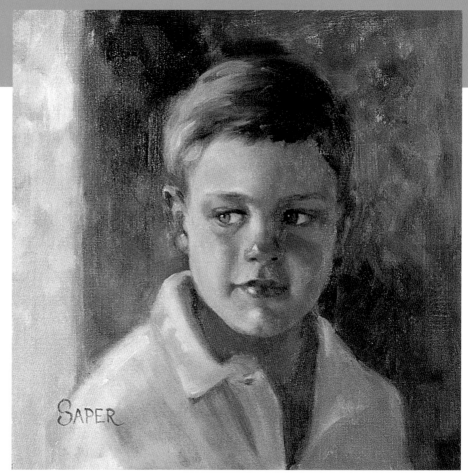

Color Bands Add Vitality to Children's Skin

Adding red-orange hues to the ears, cheeks and nose will lend a sense of freshness and health to a skin color slightly more yellow than red. The model's skin is a middle-light red-orange, slightly grayed down with green. This light source resulted in an average value change between light and shadow.

MY SON AARON
Oil on linen
12" x 12" (31cm x 31cm)
Collection of the artist

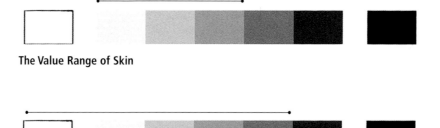

The Value Range of Skin

The Value Range of Hair

Sample Palette for Blondes: Red-Orange

Cadmium Scarlet + Cadmium Lemon

Grayed down with Titanium White + Phthalo Green

ASIAN OR PACIFIC ISLANDER

- **Skin.** The Asian skin color group covers a very broad range of color and value. The value range runs from light to middle dark; groups with the northernmost origins (such as Japanese and Korean) tend to have the lightest skin of all. Groups with geographic origins closer to the equator, such as Indian and Pakistani groups, have darker skin. In color, Asian skin tends to have relatively less red and more yellow than Caucasian groups.

 Perhaps the most striking difference between Asian and Caucasian groups is the near absence of the red middle color band in Asian groups. The distribution of color across the three bands of the face is extremely even from hairline to chin. Even in men, the relatively lighter facial hair tends to make the beard's shadow less pronounced.

- **Hair.** Asian hair falls into a very narrow value range—very dark to dark—and is characteristically black to black/brown. It is generally coarse, and tends to be straighter and smoother as a person's place of origin moves north. Moving south, Pacific Islanders' hair is wavier.

Cadmium Scarlet + Cadmium Lemon + Titanium White

Grayed down with Titanium White + Cadmium Lemon + Ultramarine Blue

Sample Palette for Asians: Yellow-Orange

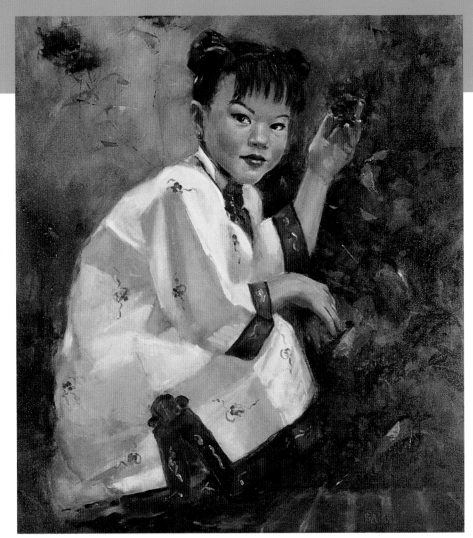

Reduce the Red for Beautiful Asian Skin Tones
Concentrate on value and even color distribution when painting Asian skin tones. This subject's skin is a middle-light yellow-orange, grayed down with blue. Flat natural light yields virtually no change in value between skin in light and shadow. Use visual clues in the features and hair to underscore the subject's heritage.

GRANDFATHER'S GARDEN
Oil on linen
30" x 24" (76cm x 61cm)

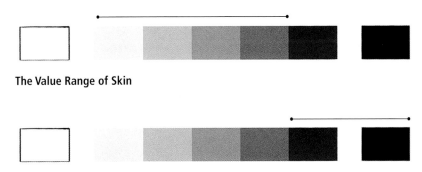

The Value Range of Skin

The Value Range of Hair

Black/African American

- **Skin.** Black skin also falls into a large range of value, ranging from middle-light to dark. In color, it ranges from a yellow-orange to a deep, grayed-down version of red-orange (commonly thought of as Burnt Sienna). Black skin may be grayed down with greens and blues. Here, there is very little red in the center color band.
- **Hair.** Black hair also falls into a rather narrow range, from very dark black and black/brown to middle browns with a yellow influence. Its texture is very curly.

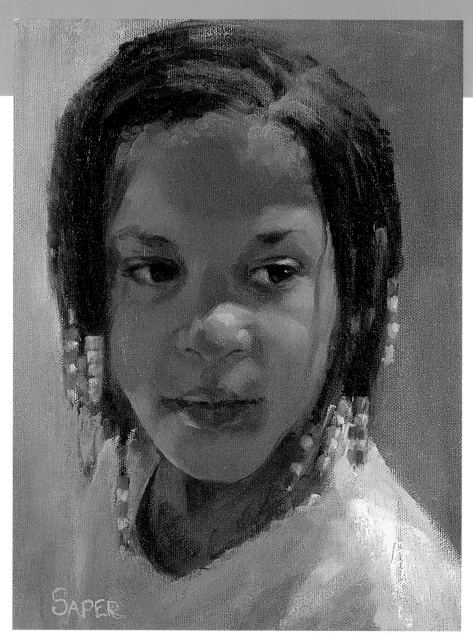

Use Beautiful Neutrals in Shadow to Support Rich Color in Light
For skin color that is more red than yellow, use green to gray down the color saturation in the shadow areas. Direct sunlight on a hazy day creates a slightly greater-than-average value shift in skin areas that are in light and shadow. The warm light source adds even more rich color to the skin touched by sunlight. The single note of blue in the beads provides visual relief to the color scheme.

GRACE
Oil on canvas
12" x 9" (30cm x 23cm)
Collection of the artist

Cadmium Scarlet

Grayed down and darkened with Ultramarine Blue

Sample Palette for Blacks/ African Americans: Red-Orange

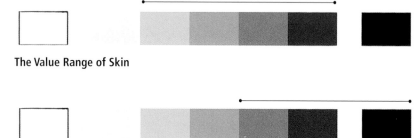

The Value Range of Skin

The Value Range of Hair

HISPANIC

As reflected in the definitions of race, Hispanics are considered to represent an ethnic group, rather than a race, and may include influences from all other races. For the sake of convenience, this section will consider the general color characteristics of people of Mexican, Puerto Rican and Cuban origins.

- **Skin.** In value, Hispanic skin generally ranges from middle-light to middle-dark. In the orange continuum, it has slightly more red and slightly less yellow influences. The center color band has less red than Caucasian groups, but more than either Black or Asian groups.
- **Hair.** Hispanic hair ranges in value from very dark to middle-dark, and can be either straight or curly.

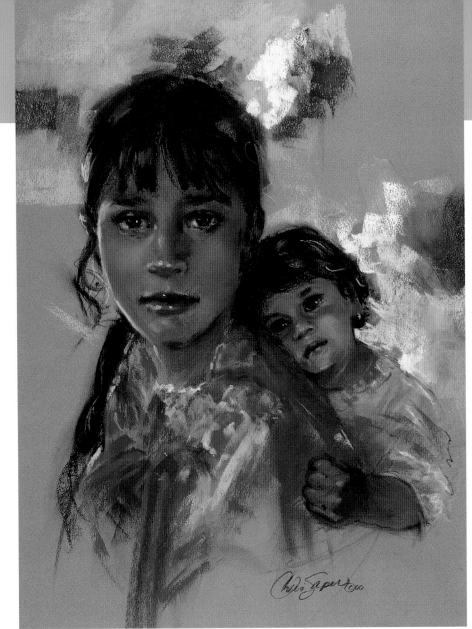

Rich Red-Oranges Convey Hispanic Skin Tones
As the strength of the light source decreases, the local color of the model's middle-value skin is more easily seen. Her face is entirely in shadow, except for a tiny note of cool blue light coming from the left. The slight presence of the red color band is often found in Hispanic skin tones.

ARTICLES OF FAITH
Pastel on Canson paper
21" x 15" (53cm x 38cm)
Collection of the artist

Alizarin Crimson +
Cadmium Lemon

Grayed down with
Titanium White +
Cadmium Lemon +
Ultramarine Violet

Sample Palette for Hispanics: Red-Orange

The Value Range of Skin

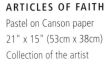

The Value Range of Hair

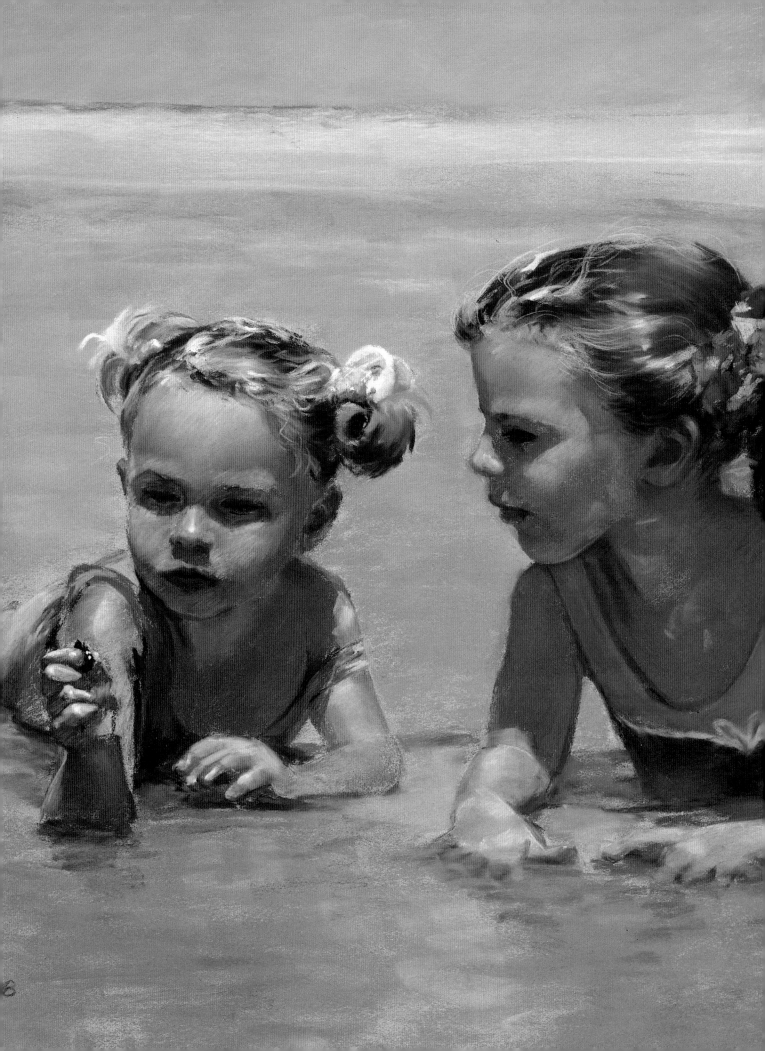

4 USING PHOTOGRAPHIC REFERENCES

One would be hard-pressed to find an accomplished portrait painter who would advocate working exclusively from photographs as opposed to working from life. Although there are purists who steadfastly refuse to paint from photographic references, you're much more likely to find artists who use a combination of sittings and photos throughout their careers. It is, in fact, the artist's base of experience in working from life that allows him to use photos most effectively, overcoming the inherent limitations of film.

But as a practical matter, painting exclusively from life is a luxury most students and few working artists actually have. From the subject's standpoint, sitting for a portrait can be grueling, even for an adult. It's patently impossible for a young child.

This chapter is devoted not only to understanding how to effectively photograph your subject, but also to understanding the limitations that are inherent in all photographs. By applying the principles that govern color in light and shadow, you can easily overcome these limitations.

SAND DABS (DETAIL)
Pastel on La Carte sanded paper
18" x 24" (46cm x 61cm)
Collection of Lauren and Georgia Hanss

Photographing Your Subject

There are two obvious advantages to working with photographs. First, models in photographs don't move. They don't change hairstyles between sittings and they don't sit in judgment at every phase of your work. You can spend as long as you want on any given stage of the painting, and you can work at your own pace.

Second, photographs allow you to capture spontaneity in your subject, and provide you with a literal snapshot of the time of day and light quality so important in outdoor settings.

SETTING UP THE POSE

As you consider how to pose your subject, keep in mind the important design principles of balanced yet unequal elements and gently flowing eyepaths.

There are classic approaches to posing the seated and standing models. They're classic because these natural resting poses were comfortable enough for the subject to maintain for many hours, long before the invention of the camera. They work beautifully for both the live and photographed sitting.

The simplest, most direct way to pose your seated subject is in a gentle "spiral." In general, choose either a clockwise or counterclockwise direction. The knees face to one side, the torso twists gently at the waist, the neck continues further and the eyes further yet.

For the standing subject, the most direct way to establish a classic pose is to simply have the subject shift his weight onto one foot. This automatically creates a *contrapposto* quality, with graceful, natural countervailing directions.

As in all painting guidelines, there are exceptions that you might deliberately want to seek out. For example, by varying the direction of the seated subject's "spiral" back and forth, you can create the feeling of tension, energy or surprise. The subject who stands at attention can convey formality, rigidity or defiance. It's up to you.

Use Your Camera to Capture Fleeting Light

Dappled or filtered light delivers wonderful visual clues to an outdoor setting. Because this light is irregular by nature, you can add believable splotches of light almost anywhere on your painting surface to support your design and move the viewer's eye. Just be certain to keep the edges appropriately soft, the values correct and the color temperature and saturation under control.

KOLLE
Pastel on Wallis paper
34" x 22" (86cm x 56cm)
Collection of Mr. and Mrs.
James K. Smith

Attend to Details Up Front

When you are taking photographs as resource material, try to include details that will help you later on. Hands are so essential to a portrait that they deserve extra attention, but be sure to notice detail in the clothing folds and hair, too.

Even the most graceful hands will look awkward in positions like the one shown at left (top), regardless of the painter's skill. Hands in peculiar positions will tend to compete with your center of interest. Shoot some extra photographs of your model's hands in better positions (bottom left), relaxed and natural in appearance.

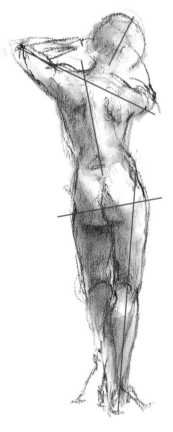

Rely on the Classics for Modern-Day Poses
The most fundamental of standing poses produces CONTRAPPOSTO, marked by graceful curves and counter-vailing balance. Even if you are just painting the head, your photos of a standing subject will add interest to the curve of the neck and slant of the shoulders.

Add Spontaneity to Your Smiling Subject
In painting a posthumous portrait, you will need to work with existing photographic material. In the case of this portrait, I worked from a flash photograph and a big grin, both of which I tend to avoid.

As it turned out, I couldn't have hoped for better results. Dr. Fisher's patients and their parents have often remarked how much this portrait captures the man they remember and are grateful to have known.

BARRY J. FISHER, M.D. (DETAIL)
In Memorium
Oil on canvas
18" x 14" (46cm x 36cm)
Permanent collection of Phoenix Children's Hospital

CAPTURING AND EXPRESSING YOUR SUBJECT'S HAPPINESS

For the most part, your clients will want the subjects you paint to look happy. Even if your subject wears an introspective expression, it need not convey a dark or brooding mood.

Although I like big toothy smiles in photographs of my own family, I have a strong personal bias against painting portraits that way for a couple of reasons. First, as soon as a smile passes a certain level, the subject's eyes begin to close. It's just the way our faces work. Second, the nasal-labial fold, which runs from the corner of the mouth to the outside of the wing of the nostril, begins to deepen. Even in young children, it will cast a deeper shadow than you'd generally want to show.

Although some painters handle smiling subjects beautifully, there are far more whose paintings look stiff, frozen in time with expressions that couldn't possibly be maintained for very long. You want to let the viewer's eyes linger as long as possible, to feel that the subject could easily be gazing back. With a grinning portrait, that can be difficult.

Painting Broad Smiles

If you feel strongly about wanting to paint a wide-smiled subject, take three precautions. First, be true to the expression. A broad smile with apple cheeks cannot coexist with wide-open eyes. Second, resist the temptation to emphasize the nasal-labial fold. Your photographs will generally give you a false reading in the shadow areas, tempting you to make them darker and deeper than would be evident in real life. And last, paint the teeth as connected shapes and forms, showing subtle variations in color and value. Do not render each tooth as a separate object.

SELECTING YOUR VANTAGE POINT

Whether you are at, above or below your subject's eye level is really a matter of preference. Subjects are often seen at their best when the artist's viewpoint is slightly above the subject's eye level. This vantage point shows a cleaner jawline, minimizes double chins and avoids having the viewer look up someone's nose.

DRESSING YOUR MODEL

Discuss clothing with your model before-hand. I generally suggest the following guidelines: Avoid high, bulky turtlenecks; small plaids and pinstripes; solid dark round-necked shirts, unless modified by a contrasting collar to break up the dark mass; and stiff fabrics or starched shirts that retain their shape instead of moving with the underlying form.

Select clothing with simple, flattering shapes. Help your subject make choices by having her bring several clothing options or by going through her closets with her. If you have the skill and temperament to paint ruffled organza and elaborately beaded satins, by all means, go for it! But even the most detail-oriented painter has to subordinate the clothing to the center of interest—the subject—for the painting to be successful.

Selecting Your Vantage Point

Position yourself just slightly above your subject's eye level, and you'll see clean, flattering jawlines and be able to avoid looking up your subject's nose. You will see many photos that adults take of children where the adult gets down on one knee and snaps the standing child. The result is a lot of throat and nostrils. By all means, experiment and enjoy the surprise of unusual viewpoints. For your commissions, though, the just-above-eye-level is a great way to go.

T.J.
Pastel on La Carte sanded paper
22" x 16" (56cm x 41cm)
Collection of Mr. and Mrs. Steve Tesdahl

Lighting Your Subject

Your first lighting decision is whether to use natural or artificial light to illuminate your subject.

ARTIFICIAL LIGHT

Lighting your subject with artificial light is fundamentally the same whether you work from life or photos. When you use photos, there are two important rules to follow:

1. Make sure the Kelvin temperature of your light source matches your film for the best color results.
2. Do not use a flash attached to your camera. Straight flat light produces boring source material and requires heroic efforts from the painter to try to compensate for it. Most electronic flash lights, unless softened by umbrellas, are too harsh. When skin

tones are normal, the shadows will be inky black.

The classic way to light the model is at an angle of about forty-five degrees from the centerline of the face, and from slightly above the model's head. This lighting position produces a beautiful triangle of light on the cheek away from the light source (sometimes referred to as the "Rembrandt effect") and avoids the design pitfall of equal amounts of light and shadow.

Be sure to place your subject away from the wall in order to separate any shadow cast by the head from the form shadow of the face.

There is a large range of direction from which you can light your subject effectively; however, avoid straight, flat light coming from your viewpoint. Artificial light also lets

you light your subject from below, an option not available with natural daylight.

NATURAL LIGHT

The same range of lighting directions are available for your subject with natural light, and any of them can be used beautifully. An excellent general approach in direct sunlight is to place your subject perpendicular to the sun, and rotate him slowly away from the light, just far enough so that he's no longer squinting. The angle of the sun about two hours after sunrise and two hours before sunset will mimic the indoor light producing the "light triangle." Earlier and later, the angles of shadows become more horizontal. Remember, the color of daylight is changing, too, and your photos will have a red-orange cast as the sun is nearer to the horizon.

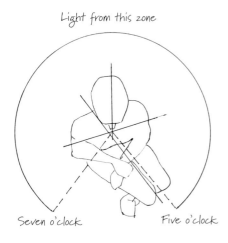

Light Your Model From Seven O'Clock to Five O'Clock

Light your model from any direction except head-on from where you are located. Avoid the boredom that comes from painting a subject whose face is lit without direction. Excitement and interest will result from the meeting of light and shadow.

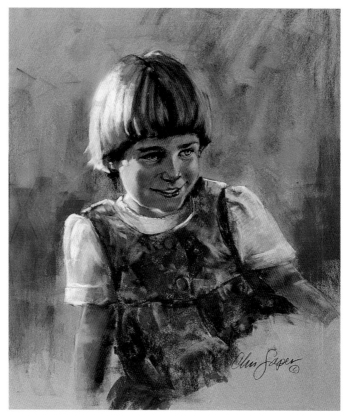

Position Your Subject for Exciting Sunlight

By turning your subject away from the sun, you can avoid having the subject squint and still capture strong, beautiful light patterns. Have your model tilt her head in several directions until the light looks just right.

PAIGE
Pastel on Canson paper
16" x 12" (41cm x 30cm)
Collection of Kathi Mansell

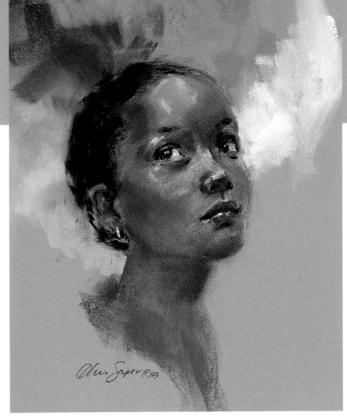

To photograph your subject outdoors under natural light, seek out places where there is an evident direction to the light. Hazy sunlight can be beautiful as it mimics the kind of light that would come through sheer draperies on a window. If the light is too flat to cast a shadow, you'll be faced with the same poor source material problem that results from a flash attachment. Have your subject slowly lift his head skyward to let the planes of his face reflect the cool blue light of the overhead sky. The use of photographs in outdoor settings allows you to capture fleeting effects of direct and dappled sunlight.

To photograph your subject indoors, you still need to find places where the light has a direction. An excellent solution is to place your subject adjacent to a large picture window. Skylights can produce beautiful lighting characteristics, too.

Lifted Faces Catch Clear Blue Light
Cool sky colors reflect beautifully on human skin. They also cool the whites of this subject's eyes to the clarity of a child's. The intensity of reflected sky increases as a person's skin becomes darker in value, shown to advantage on this Jamaican model.

SKYWARD
Pastel on Canson paper
16" x 12" (41cm x 30cm)
Collection of Ms. Victoria Gordon

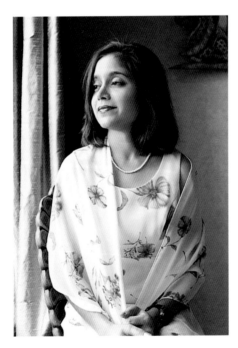

Cool Reflected Light Silvers Skin Tones
Reflections of blue and silver will bathe your model in a wonderful light. Here, normal daylight film recorded the color of light quite accurately, but sacrificed local color to do it. How you use color distortion and how far you go with it are tools within your control. Have fun with them!

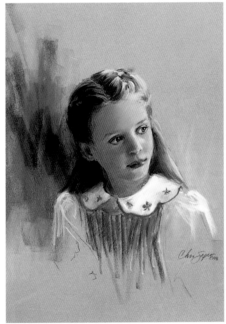

Strike a Balance Between Local Color and the Color of Light
In an identical lighting situation, I chose to paint more accurately the local color of my subject's skin, modified by the cool temperature of the light. It's a choice for this painting, but each portrait requires a fresh choice.

MICHAEL ANN
Pastel on La Carte sanded paper
23" x 17" (58cm x 43cm)
Private collection

Breaking the Chains of Photo Slavery

There are three fundamental problems that all photographs have: depth of field/focus, value clumping and color distortion. It is essential to recognize the problems if you are to conquer them. Overcoming these limitations is the key to converting your camera from a shackle to a tool.

DEPTH OF FIELD: THE FOCAL LIE

Cameras don't see the way that we do. They are designed to focus within a vertical plane, parallel to the lens of the camera. These planes are relatively shallow or deep. Objects lying within these planes are in crisp focus, and everything in front of them and behind them is out of focus.

The depth of the plane in focus is called the depth of field. At its shallowest, your camera's aperture, or f-stop, is set to its widest opening (for example, f3.5). At its deepest, your aperture is set to its tiniest opening (for example, f16).

The camera produces an image that is completely in focus for the depth of field you have used in making the exposure, like a slice (or several) of bread in the middle of the loaf. There is an equal amount of focus everywhere on the plane, along every side of the image, corner to corner.

To a camera, focus means sharp edges. The human eye, however, works entirely differently. Our eyes focus three-dimensionally, as if looking at a model of the earth's layers, where we see only the core in focus. Not only are all the other layers less focused, they progressively lose crispness as they move farther away from the core.

As the painter, you are in control of how you choose your center of interest. If you rely on the camera to do it for you, your whole canvas will be the center of interest, which is the same as having no focal point at all.

You must also control where and how you establish edge quality. The photograph cannot help you in this task because it shows that everything in focus has equally sharp edges. Based on the center of interest that you've chosen to portray, make edge decisions that will support your choice. Use the sharpest edges to grab the viewer's eye, less sharp edges to move the viewer's eye across the canvas toward your focal point, and the softest edges where you want the viewer's eye to glide.

In life, you perceive edges as soft or hard, based largely on how they look when viewing the center of interest. The experience you gain in working from life will be invaluable in training your eye to see and paint edges.

How the Camera Sees. . .
Cameras focus in vertical planes. To a camera, "focus" means equally sharp edges.

. . . and How We See
When we focus on the center of interest, surrounding objects are seen three-dimensionally and become progressively more blurry as they move farther away.

Value Clumping

The second problem inherent in photographs is the tendency for areas of relatively light and dark values to be "clumped" together. Photos distort the tonal range, so that values at either end of the value scale are compressed and show less differentiation than actually exists in nature. Dark values are more severely compressed than light values. Therefore, do not rely on the values in your photos to paint values in your portraits.

Interpret values from your photographs by teasing out only the very darkest darks and the very lightest lights as the bookend values for the painting. Extend the areas of middle value by making other areas that look dark, lighter in value, and other areas that look light, darker in value. Draw upon your experiences in working from life and observing the faces around you. Take note of how values are distributed under various lighting situations.

Reference Photo
(Photo by Linda Tracey Brandon)

Detail of the Finished Portrait

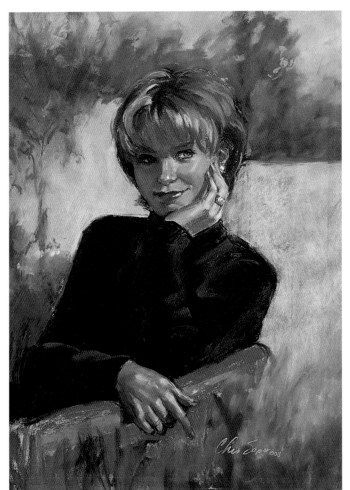

Ignore False Darks in Photo Resources

Begin by painting only the darkest darks and the lightest lights. Move all the remaining darks and lights toward a middle value. Use what you know to correct what your camera thinks it sees. The shadowed side of my face, as shown by the detail above, is made up entirely of grayed-down violets and greens, complements to the orange (red + yellow) color of the sunlight.

**BRUSH BREAK:
A PORTRAIT
OF THE ARTIST**
Pastel on La Carte
 sanded paper
22" x 16" (56cm x 41cm)
Collection of the artist

COLOR DISTORTION

When you're painting from life, you can rely on your eyes to find color. With photographs, however, you must rely on what you know about the temperature of color in light and shadow.

Regular color film is calibrated to most accurately record colors of the most commonly photographed subjects—skin tones in people and color in landscapes, such as blue sky and green grass. As a consequence, there are other colors that the film records less accurately, such as some greens, oranges, pinks and yellows, especially when they are light in value.

The film is also sensitive to green dyes used in fabrics or similar materials, and the resulting prints tend to represent greens as dull khaki, brown, yellow-green and sometimes even blue. The worst distortion occurs in shadowed areas.

Natural greens, such as in grass or leaves, normally photograph accurately. So while your green couch may look the same color as the living plants next to it, the photos you get back may not show a green couch at all.

In this photo, color distortion makes the man's white shirt appear bluish in the shadowed areas.

A less severe and generally less troubling distortion is also evident in man-made white objects, which have a blue cast and are most pronounced in shadows.

Because the bluish quality of shadows is consistently the opposite temperature of the color of direct sunlight, this distortion can often be helpful, providing a fun road map for exploiting temperature shifts. Beware, though, when painting a white shirt photographed under a cool light; you should let the shirt color warm slightly in the shadows as reflected color is introduced (see the underarm folds above).

Backlight Your Photos

One of the most helpful tools in overcoming the clumping of darks in shadows is to backlight your resource photos.

Place your photos against a strong light source so that the light forces its way through the image. Although you still won't be able to gauge value as well as when painting from life, viewing your resource photos this way will help tremendously. I tape my photos to the table lamp next to my easel.

Constructing Sensible Composites

You will often be called upon to paint more than one person in a single painting. You will rarely, however, have a single photographic resource that shows each subject at his best. The obvious answer is to provide yourself with an enormous range of solutions, or images, to follow when creating your painting.

Photo Guidelines

There are several important things you can do while you're taking pictures to maximize results. First, once you begin to take your photos, don't move. You must maintain a consistent vantage point relative to your subjects. You won't be able to combine one subject photographed from your standing height with another subject photographed from your kneeling height.

You must also maintain a consistent angle with respect to the position of the light source. Even with the same vantage point, photos taken at different times of day, or from different angles relative to the light's direction, cannot be successfully combined. You will occasionally see paintings where impossible angles have been attempted; the visual disruption is similar to a mistaken font change in the middle of a typed sentence. Look around—you'll find paintings that were painted in the "land of ten thousand suns." Thoughtful resource selection is the key to avoiding such a pitfall.

Finally, be a stickler for size. Each subject must be correctly sized, relative to the other subjects. The most practical way to ensure this is to be certain to have at least one photo in your batch that allows you to compare subjects. Knowing, for example, that John's head is about 80 percent of the size of Susan's head gives you an excellent sizing guideline that you can use throughout the painting, regardless of the ultimate composition you choose.

Give Yourself Options
Both children have great expressions (a rarity in one shot!) and the lemons look good, too. But the body language of both children is awkward and won't contribute to a successful design.

Here, the little girl's graceful pose and natural affection for her brother are captured. Neither the children nor I have moved from our initial starting points.

Select the Pose You Desire
The boy's pose in this shot is perfect to complete the composition. Having both children in any one photo provides relative sizing information. Because I do so much outdoor photography, I always carry a green towel in my car in case of wet grass. A ground cloth similar in color and value to the setting will not introduce illogically reflected color.

Create the Composition You Want

Composing the painting from a variety of reference photos requires much more time in the up-front drawing and designing phases, but produces a result that's well worth the energy. With settings like this, you can feel free to alter the light and shadow pattern on the grass to support the eyepath and composition.

THE LEMON GATHERERS
Pastel on Wallis paper
18" x 32" (46cm x 81cm)
Private collection

Painting From Life vs. Painting From Photographs

Should you paint from life? Absolutely. Use every opportunity you can find to observe a real subject in three dimensions, in living color. Should you stand on ceremony and refuse to paint from photographs? Absolutely not. Even if you have the daily luxury of painting from life, you should understand how to paint effectively from photos, too. You'll make more progress painting every day from photos than you will painting once a month from life. Do your best to paint both ways every chance you get.

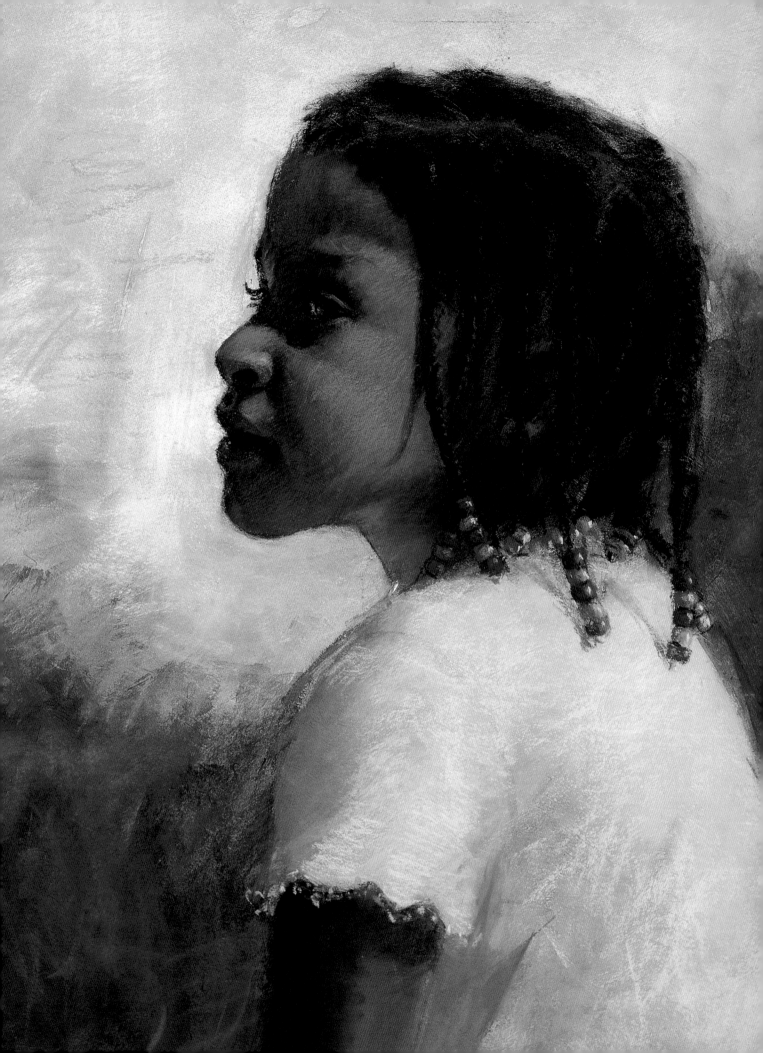

5 ORGANIZE YOUR PAINTING IN THREE EASY STAGES

In this chapter, you'll become familiar with some tips and tools to help make your portraits consistently better. Although the process of painting clearly requires an integrated approach, there are some simple and necessary decisions to be made along the way, and they should be made in a logical sequence. Painting decisions can be grouped into three stages: early, middle and final.

The early decisions you will make include selecting the center of interest, resolving the portrait's compositional plan or design, identifying the color of the light source and selecting the color harmony. Take time to think before you paint. Middle decisions, which occur during the painting process, include working the likeness and making color choices. And the final decisions involve proofreading your portrait and considering the center of interest and the composition's effectiveness, determining if there is unified color temperature and harmonious color, reviewing the edges and color discords and, finally, deciding where to place your signature.

Each of the demonstrations in this chapter will illustrate the use of various tools that will save you time and aggravation from beginning to end, allowing you to enjoy the process of painting. Through your own experimentation, you can decide which of them work for you and under what circumstances.

JESSIE'S BRAIDS (DETAIL)
Pastel on Wallis paper
16" x 18" (41cm x 46cm)
Collection of the artist

Using a Three-Value Thumbnail Sketch

Materials List

- Surface: Belgian linen canvas
- Brushes: variety of bristle filberts, nos. 2 through 8
- Turpenoid
- Standard oil palette, including:

 Terre Verte (for drawing) Cadmium Lemon
 Cadmium Scarlet Ultramarine Violet
 Alizarin Crimson Ultramarine Blue
 Phthalo Green Titanium White
 Ivory Black

Finished Painting

*T*hree-value thumbnail sketches are a valuable tool in the early decision-making stage of the painting. They take only a few minutes to do and can save you hours of frustration later. Through them you can resolve questions about whether your painting should be about light or shadow, how you can best arrange a value pattern in either horizontal or vertical format, and how you can best place your subject to support a beautiful and effective design.

EARLY DECISIONS: THINK BEFORE YOU PAINT

- **Identify the center of interest.** In this case, the focal point will be Isabel's left eye (on our right).
- **Determine the compositional design through three-value thumbnail sketches.** This will be a portrait about light.
- **Determine the color of light.** Isabel posed next to a large, north-facing window. The indirect light is cool and blue, leaving the shadows to run warm.
- **Determine the color harmony** (complementary yellow-violet).

1 | Create a Three-Value Thumbnail Sketch

Quickly sketch your subject within a small rectangle, up to about 4" × 6" (10cm × 15cm), proportional to the canvas you will be using. Make copies (tracing paper is quick and easy to use) so you can experiment with different value plans.

Shade in blocks of shape representing light, middle and dark areas of the sketch.

Try to force everything into three simple values. Consider shapes on the rectangular plane, as well as the foreground, middle ground and background.

Try several compositional arrangements: light against dark against middle; light foreground and background with middle and dark values in the middle ground; and light against middle against dark. Choose the one you prefer. I prefer the middle arrangement.

By choosing that one, three important decisions are made: (1) This portrait is about light rather than shadow, (2) a general value plan that considers both negative and positive spaces is established, and (3) the head is placed in a horizontal format.

Experiment with moving the borders, if you wish. When you're satisfied with your value sketch, find the center and mark it.

2 | Prepare Your Canvas

Tone your canvas with a thin wash of Terre Verte and Turpenoid. The green tone is a wonderful foil for skin, as well as a great drawing color. Find the center of the canvas and mark it to correspond to the center of the thumbnail sketch.

MIDDLE DECISIONS:
THE PAINTING PROCESS

- **Work the likeness.** Even though your drawing will be obliterated as soon as you begin applying color, it's an important dress rehearsal for the painting. Drawing gives you a visual memory of your subject's face and the confidence to know that if you can do it once, you can do it again. There are many ways to begin a drawing: line, shape, outside-in or inside-out. Use whatever works best for you.
- **Make color choices.** An olive-skinned brunette, Isabel's skin is middle-light in value, slightly more yellow than red, and grayed down with green. Mix two piles of color—one to approximate the average value and color of her skin in light, and the other for skin in shadow. Since the light source is cool, keep the light colors cooler than the shadow colors. Mix a variety of hues into each pile without changing the value of the original piles. You'll have a fresh menu of colors available for either light or shadow.

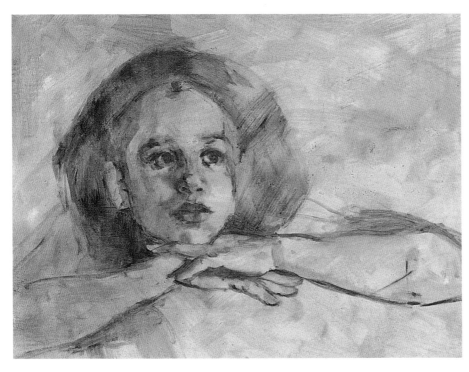

3 | Draw the Portrait

Using a no. 2 bristle filbert (or any brush with a small, stiff tip), draw the portrait with thinned-down Terre Verte. As a painting becomes larger, the difference between the thumbnail sketch and full-size painting becomes more pronounced. If you feel you need to rethink the placement or value plan, do so now.

Locating the Center

When you work on a fixed support, locating the center is extremely important. Otherwise, you'll lose the relationship between negative and positive shapes that you worked out in the value plan. You will get more "wiggle room" when you work on paper that can be cut or matted to fix compositional errors. Remember that the frame's rabbet (rebate) will cover ⅜" (10mm) on each side.

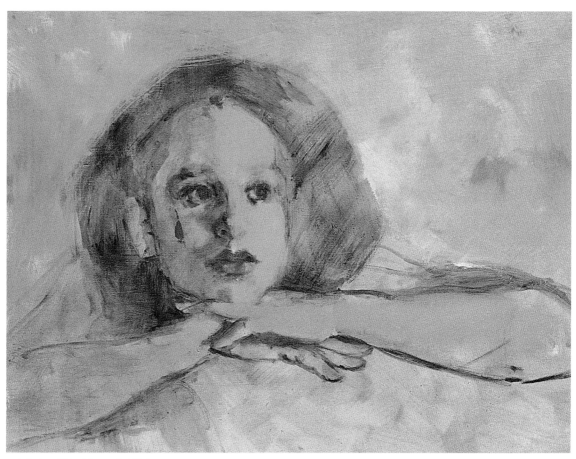

4 | Paint Skin Tones in Light

Mix a pile of average skin color in light.
Create a menu of different hues by adding
clean cool blues, green-violets and reds.
Keep values close.

Base +
Phthalo Green

Base +
Ultramarine Blue

Base +
Alizarin Crimson

Base +
Ultramarine Violet

Basic Light Colors

Base Color =
Cadmium Scarlet +
Titanium White +
Cadmium Lemon,
grayed down with
Ultramarine Violet

The Drawing Stage

When you paint from photos, take as long as you'd
like in the drawing stage. When you paint from
life, you must make decisions quickly, such as
locating your center, rapidly placing the head and
locating features in an undetailed, yet accurate
manner. What you may give up in terms of tight
likeness will be regained by the spontaneity
inherent in a fresh, quickly done portrait.

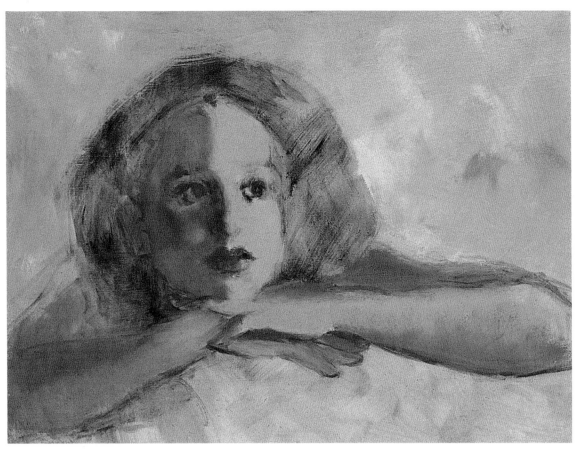

5 | Paint Skin Tones in Shadow

Colors in shadow will be warmer than those in light. Create a comparable menu of shadow colors, maintaining value and temperature relationships. Keep warm, strong reds along the shadow cores, even where the edges are soft.

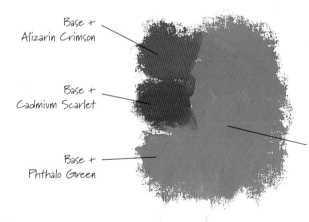

Base +
Alizarin Crimson

Base +
Cadmium Scarlet

Base +
Phthalo Green

Base Color =
Cadmium Scarlet +
Ultramarine Blue,
grayed down with
Titanium White

Basic Shadow Colors

6 | Place the Darkest Darks

Establish your darkest value early on. This will become the book-end against which you will judge other values.

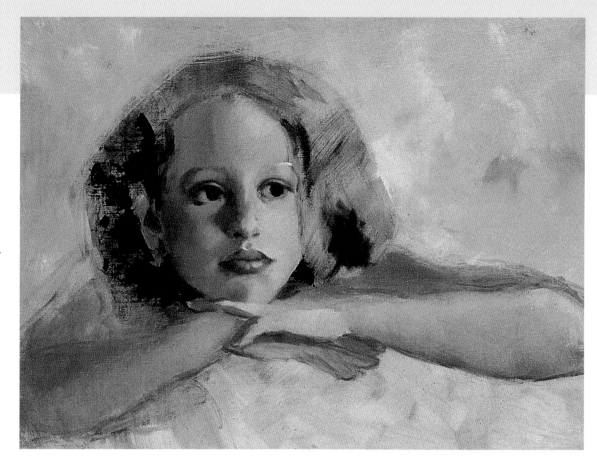

7 | Complete the Painting

Use value changes to create volume as you refine the color and likeness. Always keep in mind the temperature differences between light and shadow.

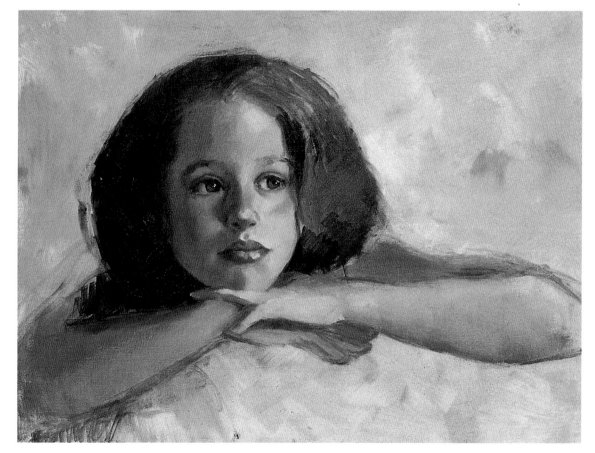

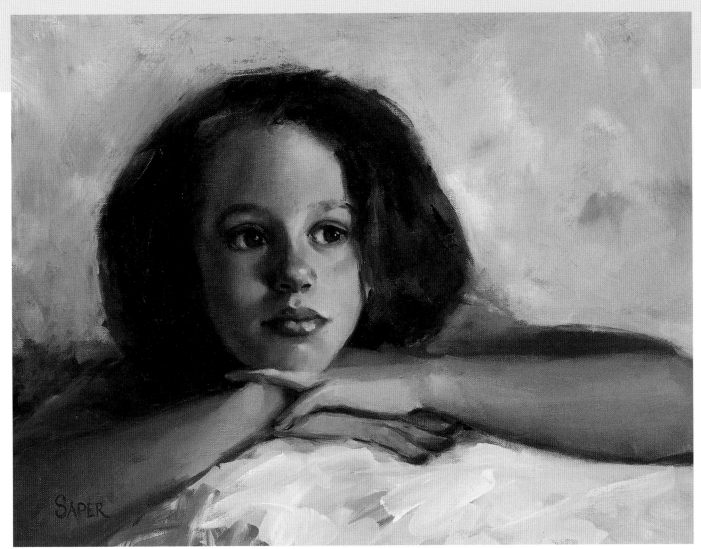

FINAL DECISIONS: PROOFREADING YOUR PAINTING

- Is the center of interest clear? **Yes.**
- Is the composition effective? **Yes.**
- Are color temperatures unified? **Yes.**
- Does the color harmony work? **No.**
- Are the edges effective? **Yes.**
- Is a discord needed? **No.**
- Is the signature needed? **Yes.**

8 | Proofread Your Work and Finish

To add balance and strength to the complementary color scheme, the lighter grayed-down violet in the background needs to be offset by saturated yellows in the foreground. Temporarily place the painting in a frame to see where the rabbet (rebate) will crop the canvas and then add your signature. Here, I placed it in the lower left corner.

When you make your early decisions at the right time, you'll find that the adjustments necessary to complete the painting are straightforward and easy to accomplish. In this case, all that's required is a brighter, stronger yellow to punch up the complementary color harmony, and the placement of the signature.

ISABEL
Oil on canvas
12" x 16" (30cm x 41cm)
Collection of the Candyce
and James Hines Family

Rescuing a Poor Photographic Reference

Materials List

- Paper: Canson Mi-Teintes, Burgundy
- 6B charcoal pencil
- Kneaded eraser
- Soft pastels, 15 sticks (see color reference)

Sometimes you'll need to work with a photo with worse than average color limitations. Use what you know about the color of light to create exciting, energetic skin tones. In this demonstration, Eric's portrait is painted without any true skin color—I used only the color of light.

Reference Photo

EARLY DECISIONS: THINK BEFORE YOU PAINT

- **Identify the center of interest.** Eric has a centered presence about him and an even, wide-set gaze that imparts a sense of calm. It's rare to find a subject with such regular and beautifully sculpted facial planes. The structure of his face and skull is most evident in the core of the shadow separating light and dark, and this will be the focal point of the painting.
- **Determine the compositional design.** This portrait will be a painting about shadow. The color of the light itself will provide all the design elements needed to support the vignette.
- **Determine the color of the light.** Resource photos for this painting were taken just before sunset, when the light striking Eric's head was red-orange. While the majority of his face is in shadow, it's strongly illuminated by the clear blue sky.
- **Determine the color harmony** (analogous violet). The pervading sense of cool shadows suggests a red-violet/blue-violet color scheme. Canson's burgundy Mi-Teintes paper supports the color harmony.

MIDDLE DECISIONS:
THE PAINTING PROCESS

- **Work the likeness.** In drawing a portrait for a vignette, it's generally a good idea to center it from right to left and to place the head closer to the top than the bottom of the page. This will give you some cropping flexibility at the end. Sizing a head 75 percent of life-size gives a comfortable feel and leaves enough room for detail.

- **Make color choices.** Eric's skin is middle-dark in value. Since no true skin color will be used in this portrait, the type of orange in his skin isn't relevant. Instead, it's necessary to concentrate on the temperature and saturation of colors in the light and shadows.

Correcting Competing Colors

In keeping with the principle of unequal balance, the light blue cannot compete with the light yellow. Solve this problem by using a smaller quantity of blue that is slightly darker in value and slightly lower in saturation than the yellow.

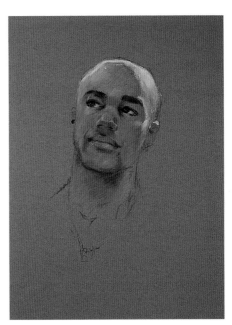

1 | Work the Likeness

Using a soft charcoal pencil, indicate the placement of the head and enough facial detail to feel comfortable introducing color. Sketch lightly so as not to score the paper's surface.

2 | Model the Head with Colors of Light and Shadow

Paint skin in shadow with three sticks of pastel that represent the complement of the color of the red-orange light source. Choose a grayed-down blue, matching the middle-dark value of the paper, and two middle-value sticks, one in blue and one in blue-green.

Paint the skin in light using middle-dark red and orange. Establish the lightest values in the painting: a light yellow meeting a light blue at the top of the skull.

3 | Model the Features

Use black, modified by the other darks you've already used, to paint the features, always observing the three rules of shadow: reduced contrast, reduced saturation, controlled edges. Unify colors with a stick of middle-value grayed-down yellow-green.

Turn the form by painting the cores of the shadows with saturated middle-dark sticks in red and red-orange.

FINAL DECISIONS: PROOFREADING YOUR PAINTING

- Is the center of interest clear? **Yes.**
- Is the composition effective? **No.**
- Are color temperatures unified? **Yes.**
- Does the color harmony work? **Yes.**
- Are the edges effective? **Yes.**
- Is a discord needed? **No.**
- Is the signature needed? **Yes.**

Although the vignette holds together okay, it would be much more exciting to add an energetic background, punctuated by the use of color discords in cool yellow and blue-green.

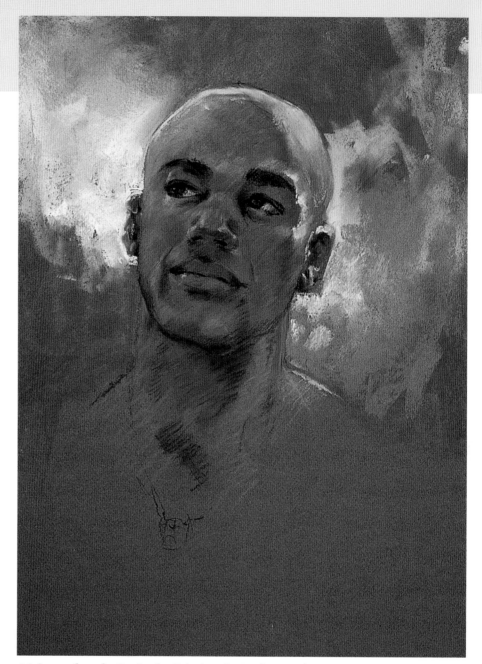

4 | Strengthen the Design by Painting the Background

Using only the colors already on your palette, place broad, scrawling strokes of color, shifting the temperatures from left to right. Integrate the lower edges of the background with the paper.

Establish Background Early

It's always better to establish your backgrounds at the beginning. To add them at the end, you need to mirror other choices you've already made: (1) Preserve harmony by using existing colors, (2) maintain the balance between light and shadow, and (3) keep cool and warm areas distinct.

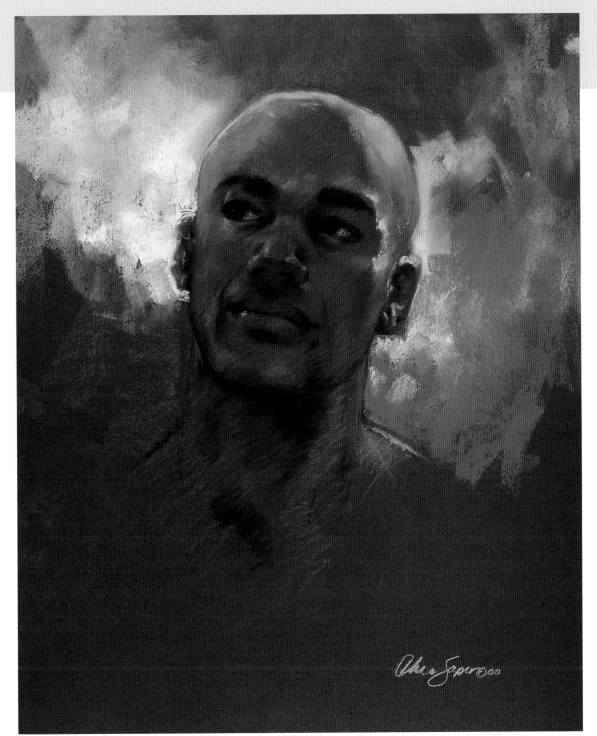

5 | Adjust Negative Spaces by Cropping Carefully

Determine the best placement of the mat (or frame) to balance
negative spaces. Place the painting in its mat before adding your
signature. Accept that the signature will be part of the design and
make it work for you by controlling its placement, size and color.

ERIC
Pastel on Canson paper
18" x 14" (46cm x 36cm)
Collection of the artist

Develop an Edge Plan to Make Your Point

Materials List

- Paper: Arches 140-lb. (300gsm) cold-press
- Brushes: 1-inch (25mm) flat sable, no. 8 round sable
- Turpenoid
- Standard watercolor palette, including these Winsor & Newton colors:

 Rose Madder Genuine Cobalt Blue
 Alizarin Crimson Viridian
 Raw Sienna Burnt Sienna
 Aureolin

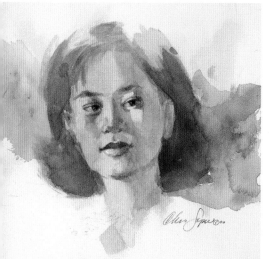

Finished Painting

Making an early edge plan helps you think through both the portrait's design and how to move the viewer's eye to your focal point. Edge plans are useful in every medium. In oil and pastel, they're valuable to help you stay focused on the center of interest, although they almost always need to be adjusted and restated as part of the proofreading stage. In watercolor, however, edge plans are much more important since edge decisions can be difficult, if not impossible, to change once a wash is dry.

EARLY DECISIONS: THINK BEFORE YOU PAINT

- **Identify the center of interest through the edge plan.** The small area of light tumbling across Sue's left eye (on our right) perfectly describes the beautiful structure of her eyelid, which will be the portrait's focal point. Crisp edges, strong contrast and saturated color will work together to move the viewer's eye to that point.
- **Determine the compositional design.** This portrait will be high key—a painting about light. Relate the subject to the background through lost and found edges, connecting light and dark values to the edge of the frame or mat.
- **Determine the color of light.** The light source is a warm yellow-orange filtered through a screen. As a result, the shadows are cool and soft, with reduced contrast between light and shadow. Changing temperatures are as important as changing values to depict shadow.
- **Determine the color harmony.** A complementary yellow-violet harmony is a simple approach to warmly lit skin tones and violet-based shadow.

1 | Plan Your Edges Up Front

Since the focal point is the eye on our right, the shadows on the lids and the shape of the iris will have the sharpest edges in the painting. Consider several secondary edges located in places that will encourage the viewer to return to the center of interest, such as the eye on our left, the inside corner of the mouth and the edges of the jaw.

Losing the top edge of the hair entirely into the white of the paper accomplishes two things: First, it anchors the head to the background; second, it provides visual interest to break up a monotonous silhouette.

Middle Decisions:
The Painting Process

- **Work the likeness.** Watercolor doesn't lend itself well to unlimited reworking of the surface, so draw lightly but with enough accuracy to see where you're going with the likeness. The more accurate in the beginning, the fresher you can keep the final piece.
- **Make color choices.** Decisions about basic hues are straightforward: Grayed-down yellows represent the light areas of the painting and grayed-down violets represent the shadows. Each has a variety of colors dropped in, but overall they observe the separate temperatures of light and shadow.

2 | Paint Basic Skin Tones in Light

Sue's skin is light in value, slightly more yellow than red, and warmed further by the light source. Use a 1-inch (25mm) flat sable brush to cover the skin tones with Raw Sienna, extending into the hair and background. Drop in bits of Rose Madder Genuine before the wash dries. Using a violet mixed from Cobalt Blue and Rose Madder Genuine, add a wash of similar value to the areas of hair, also connecting it to the background. Let it dry.

3 | Paint Skin Tones in Shadow

Switch to a no. 8 round sable brush and paint the shadow pattern on the face. Paint the sharpest edge along the shadows of the eyelid on our right and leave it. Use a green mixed from Viridian and Aureolin for the skin farthest from the light source; warm the cores of the form shadows with orange mixed from Aureolin and Rose Madder Genuine. Model the left side of the face. Let it dry.

4 | Place Secondary Edges as You Model the Features

Continue modeling the features, placing each secondary edge as you go. Correct the sharpness as soon you paint the edges, always keeping them subordinate to the focal point. Use Burnt Sienna and a mixed black (Alizarin Crimson + Viridian) for the darkest areas of the eyes and brows. Let it dry.

5 | Complete the Hair and Proofread Your Work

Loosely wash in the shape of the hair with the mixed violet.

FINAL DECISIONS: PROOFREADING YOUR PAINTING

- Is the center of interest clear? **Yes.**
- Is the composition effective? **No.**
- Are color temperatures unified? **No.**
- Does the color harmony work? **Yes.**
- Are the edges effective? **Yes.**
- Is a discord needed? **No.**
- Is the signature needed? **Yes.**

 The composition is improved by attaching the head to the background with color. Using warm connectors on the left side of the paper also corrects the temperature error on the left side of the hair. Only after the final cropping is it possible to place the signature.

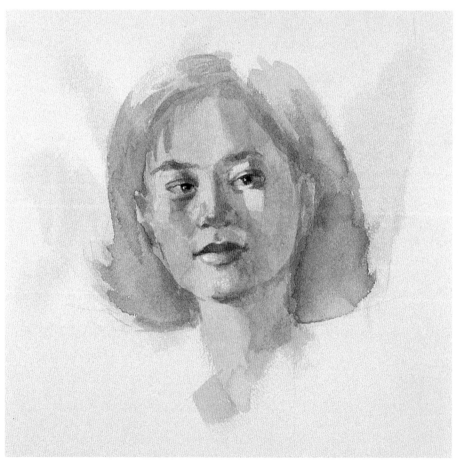

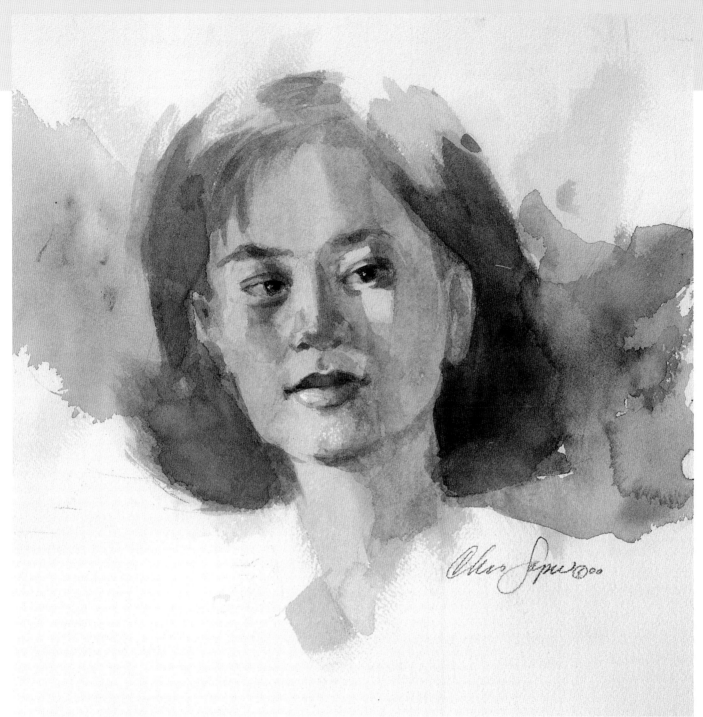

6 | Correct the Portrait

Darken the shadow side of the hair, connecting it to the background with a violet wash.
Correct the color temperature of the light side of the hair by warming it with Raw Sienna,
connecting it to the left edge of the paper. Crop the portrait and place your signature. I
usually sign my watercolors with pencil, but you may wish to use paint. Choose a color
and value compatible with your finished work.

PORTRAIT OF SUE
Watercolor on Arches
 cold-pressed watercolor
 paper
14" x 11" (36cm x 28cm)
Collection of the artist

Integrate Material With Strong Color Harmony

Materials List

- Paper: La Carte sanded paper, light gray
- 6B charcoal pencil
- Kneaded eraser
- Soft pastels, 21 sticks (see color reference)

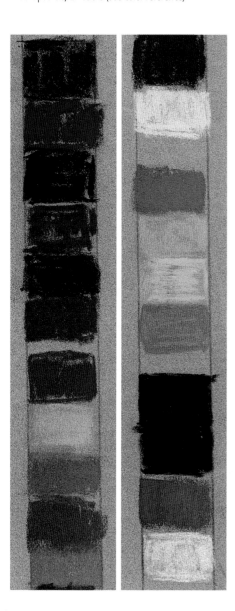

Here's a great example of how you can successfully combine photos with different backgrounds by using a color harmony of your own choosing. You have to do it in the planning stages in order to get an end result with beautiful, unifying color.

EARLY DECISIONS: THINK BEFORE YOU PAINT

- **Identify the center of interest.** Everyone who meets Eunice is immediately taken with her extraordinary eyes and beautiful, full mouth. In this painting, the eye on our left, under its sculpted brow, is the center of interest; her lips are the secondary focal point.
- **Determine the color harmony.** In reviewing the various photo resources, it's impossible to disregard the fantastic red-green complementary color harmony presented by the blooming bougainvillea. With thoughtful color considerations, you can combine this background with the preferred face photos.
- **Determine the color of light.** The light on Eunice's face is a filtered warm yellow-orange; therefore, the shadows are cooler than the light areas. However, the bougainvillea is indirectly lit with cooler light, giving a cool red-green image. To make this color harmony support the warmth of Eunice's skin, the background needs to be brought up to the temperature of the light on her face.
- **Determine the compositional design.** Skin tones constitute the only light areas of this painting, punctuated by the very dark values in the hair. In order to retain the intense color saturation of the background foliage, the reds and greens must be kept at

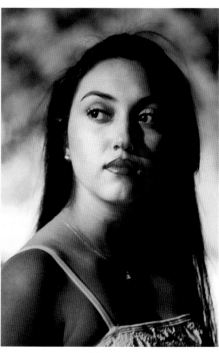

1 | Pose Your Subject

This photo of Eunice shows a comfortable contrapposto pose, Rembrandt-like lighting and a beautiful, serene expression. The light source, although filtered, is a warm yellow-orange.

their highest saturation, forcing the background into a middle to middle-dark value range. In this example, the painting's design is created by strong color patterns. Red moves the viewer's eye from the upper left of the painting to the middle-lower right. Strong lip color acts as a visual stepping-stone.

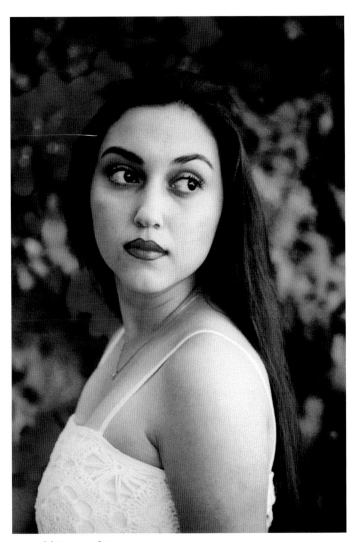

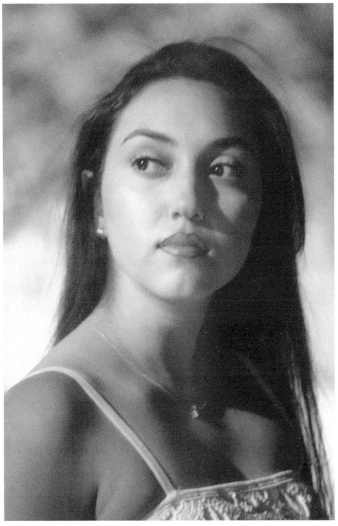

2 | Add Items of Interest

This bougainvillea is simply too spectacular to pass up! Built-in color harmony and interesting patterns make their inclusion perfect. The tropical feel of the bougainvillea sets up a strong clue for a Hispanic subject. The light source is indirect and quite cool.

3 | Determine the Values of Your Colors

A photo-quality black-and-white image can help you think through the final colors in the painting without becoming confounded by the fighting temperatures in the photos. In this high-quality scanned photo, the value clumping of color shadows is actually reduced. Be aware, though, that normal black-and-white photocopier images generally worsen value clumping and are of limited use.

MIDDLE DECISIONS: THE PAINTING PROCESS

- **Work the likeness.** Use a 6B charcoal pencil to lightly sketch the portrait. Despite the great ability of the La Carte paper to accept opaque layers of pastel, the surface scores easily with a sharp point. It's difficult to cover the scratches, so easy does it.

- **Make color choices.** In a painting like this, it's essential to commit to the background immediately. First, you'll establish a saturation bookend since the background foliage contains the most intense colors. The intensity of all the other colors used in the skin tones can be judged in comparison to the background reds and greens. By stating color temperature early, it's easier to make good color temperature decisions later.

 Eunice's skin color is middle-light in value, slightly more yellow than red and grayed down with green. Her skin color is beautifully balanced in color from hairline to chin, which is so characteristic of Hispanic subjects.

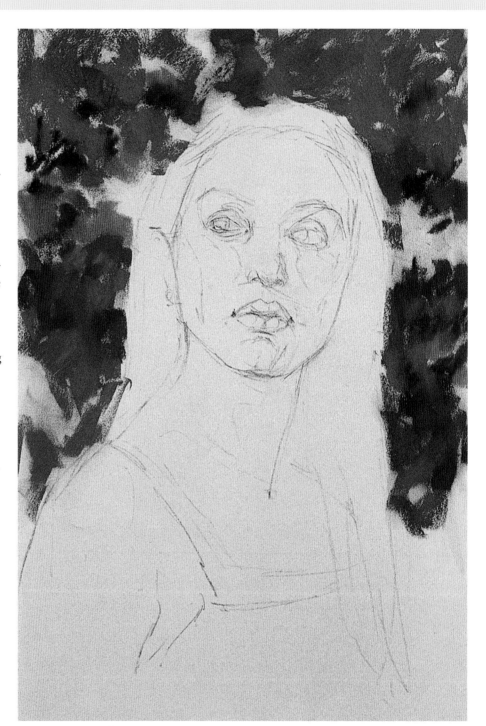

4 | State Your Color Harmony Up Front

Once you've sketched your subject, make a bold background commitment right away. Establish the eyepath with fully saturated greens and violets for the foliage and fully saturated reds for the blossoms. To support the face's skin tones, add warmer and cooler versions of red and green to the background.

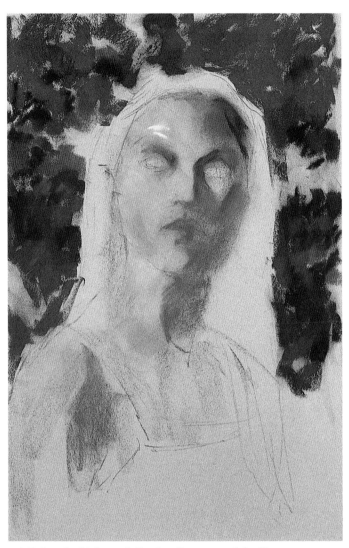

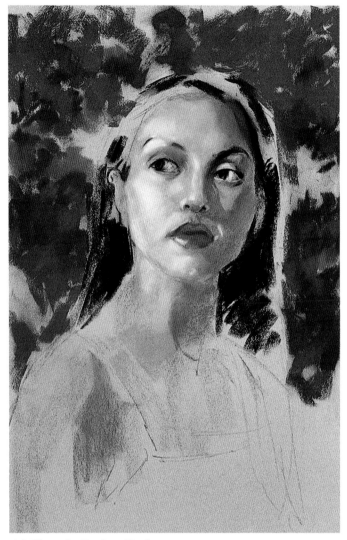

5 | Paint the Light and Shadow Patterns of the Face

Paint the light skin tones with warm yellow-orange, approximating the average value and hue of Eunice's skin in light. Paint the shadow shapes, concentrating first on the value relationships. Adjust the color temperature so that the lights are clearly warmer than the shadows.

6 | Place the Darkest Darks

Paint the darkest darks with black and very dark brown. Establishing the darkest values in the painting gives you a value bookend and helps you begin to work the likeness.

7 | Model the Features

Model the structure of the face with slight value and color shifts, and increase attention to each feature. Keep color temperatures in light and shadow separate, making sure that the values and edges all support the eye on our left as the center of interest. Repeat the saturated reds of the bougainvillea in the lips, using slightly less saturated hues to turn the forms at their shadows' cores. Even very strong color will work in skin tones, since it will look subtle compared to the fiery colors of the background. Place a note of light yellow-green to test how light and warm the foliage colors can go.

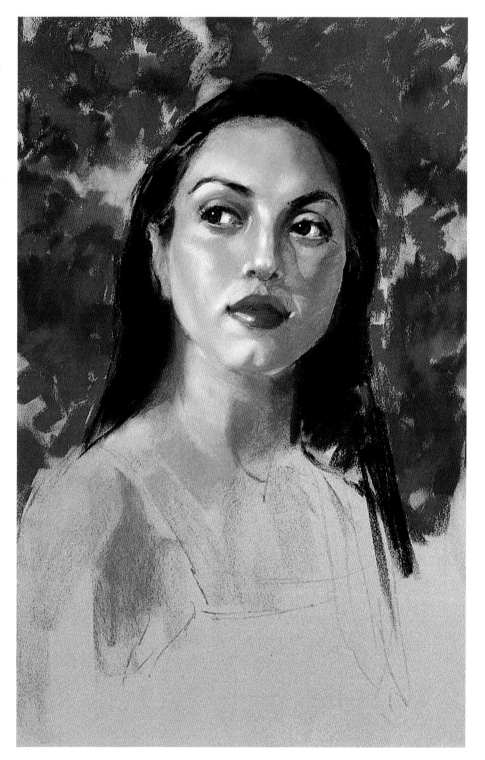

FINAL DECISIONS: PROOFREADING YOUR PAINTING

- Is the center of interest clear? **Yes.**
- Is the composition effective? **Yes.**
- Are color temperatures unified? **Yes.**
- Does the color harmony work? **No.**
- Are the edges effective? **Yes.**
- Is a discord needed? **No.**
- Is the signature needed? **Yes.**

A happy proofreading outcome is much more predictable when you make all of the immutable decisions at the right stage in your painting. Even if you identify several finishing tasks, they'll be in areas that can be readily adjusted.

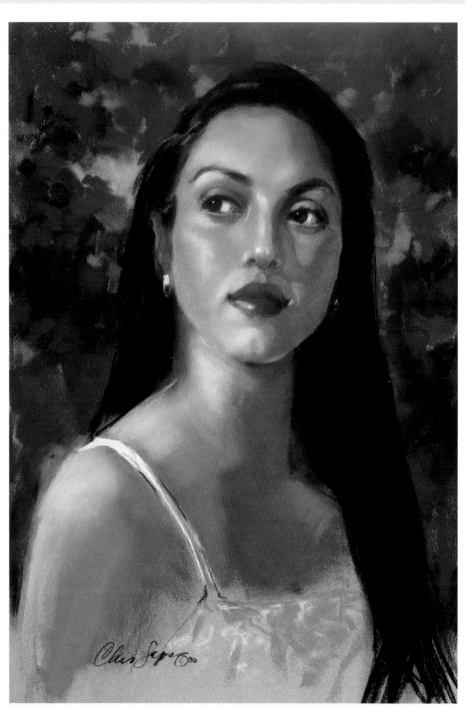

8 | Complete the Portrait

Refine and restate the reds and oranges of the flowers, and fill in the foliage with a sprinkling of various greens, integrating the light yellow-green throughout the entire background. Using loose, broad strokes, complete the lower part of the painting. Place the signature, and you're done!

EUNICE
Pastel on La Carte
 sanded paper
18" x 14" (46cm x 36cm)
Collection of the artist

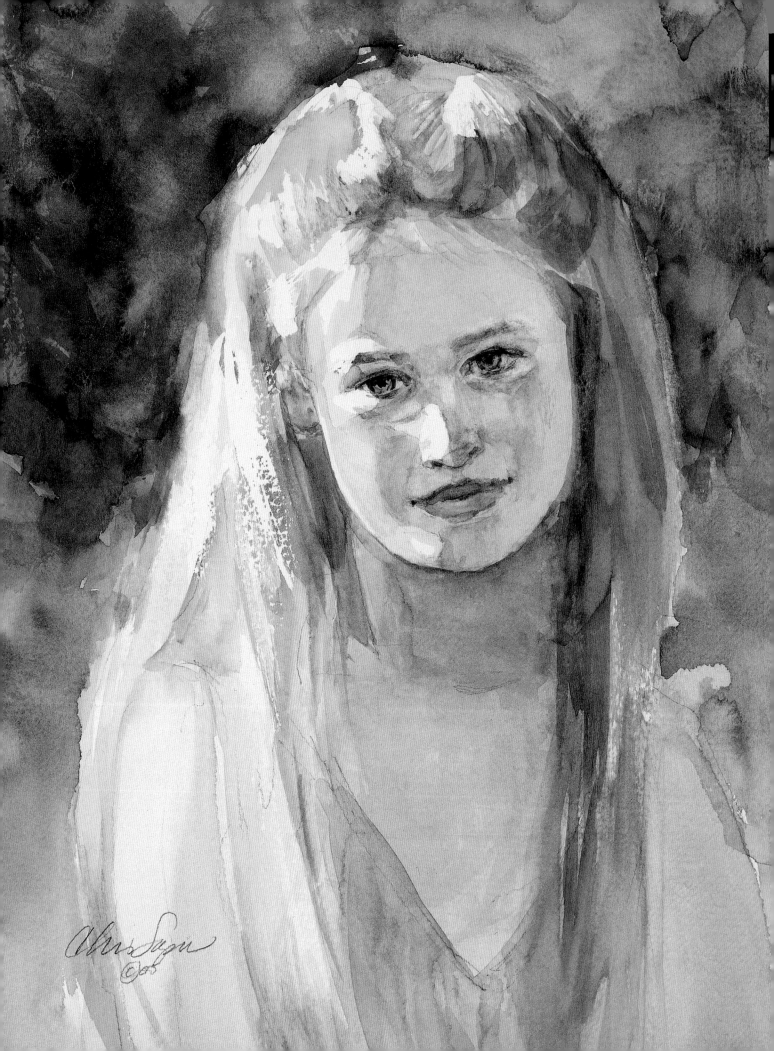

6 PAINTING DEMONSTRATIONS STEP BY STEP

In each of the following demonstrations, the same decision-making outline is followed. Organizing your thoughts in early, middle and final stages is a practical way to approach a portrait. Your results will not only be more beautiful, they'll be more predictable.

All the principles discussed in this book come into play as each painting is developed. But to paint beautiful skin tones, none is more important than understanding the color of light.

KATHARINE
Watercolor on Arches 140-lb. (300gsm) paper
15" x 10" (38cm x 25cm)
Collection of the artist

Skin Tone, Indian Subcontinent (Asian)

Materials List

- Paper: Canson Mi-Teintes, Light Grey
- 6B charcoal pencil
- Kneaded eraser
- Soft pastels, 26 sticks (see color reference)

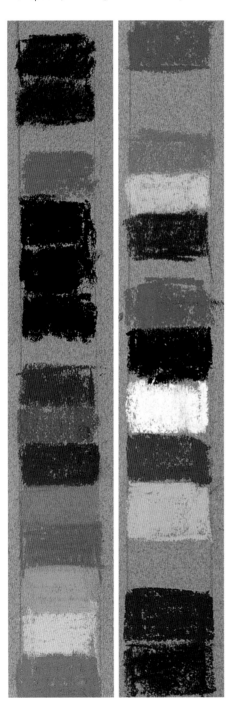

Begin this portrait in the same way you begin every portrait: by observation and with thoughtful decisions. My subject has ethnic origins in the Indian subcontinent. The local color of her skin is a middle-value orange, grayed down with slightly more blue than green. Characteristic of her Asian/Indian origin, the bands of color across the top, middle and lower thirds of her face are extremely even. This demonstration will be painted as a classic vignette.

EARLY DECISIONS: THINK BEFORE YOU PAINT

- **Identify the center of interest.** The expression conveyed by the subject's left (our right) eye and the slight lift of the brow convey serenity, optimism and humor, and will be the focal point of this portrait. The sharpest edges will need to be at the center of interest, with movement supported by secondary edges at the jawline on our left and on the shawl, where the light and shadow meet.
- **Determine the compositional design.** Ordinarily, this is the point where you would do a three-value thumbnail sketch. But for this demonstration, a thumbnail isn't really necessary. First, the pattern of light and dark is straightforward: The hair and eyes are dark in value, the areas lit by direct sunlight are light and the face and background are in the middle. Second, because this painting is a vignette, you can crop the paper at the end, leaving negative spaces that are pleasing in shape and proportion.
- **Determine the color of light.** The reference photo for this painting was taken in the late afternoon with direct sun lighting the subject. Therefore, the color of the direct sunlight is a very warm orange (probably about 2500K to 3000K). However, the entirety of her face is in shadow, illuminated only by the indirect cool light

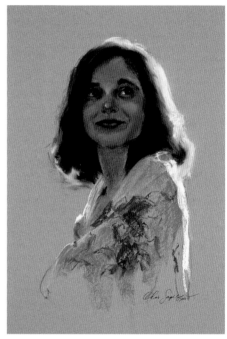

Finished Painting

from a clear blue sky (probably about 12000K).

- **Determine the color harmony.** The relatively cool hues in the skin tone suggest a blue-violet analogous color harmony, adapted for portraits with the addition of orange. Since this portrait will be a vignette, selecting the background color is essential. To support the sense of cool skin tones, choose a cool neutral paper. In this case, a gray with a middle-light value was used, allowing contrast between the paper and both the dark and light areas.

1 | Place the Head and Declare the Coolest and Darkest Areas of Skin

Using vine charcoal or a very soft 6B charcoal pencil, place the head in the general center of the page, slightly smaller than life size, about 7" (18cm) from the chin to the top of the hair. Using a very light touch, indicate the gestural direction of the head, neck and shoulders, and indicate the placement of the features. Continue this light drawing until you have a road map of the likeness and directional feel of the painting.

Select two pastel sticks similar in value, but opposite in temperature: a dark, grayed-down violet and a dark, grayed-down red. Because there is so little value differentiation across the surface of the skin, it's necessary to rely on temperature shifts, rather than simply value changes, to indicate volume. Since the subject's face is illuminated with cool light, the upward-facing planes of her face will be slightly lighter in value and relatively cooler in temperature than the downward-facing planes.

Use the two pastel sticks to indicate the relatively darker areas of her face, as well as the downward-facing planes. Use your fingers to smooth the painted areas so that the paper doesn't show through. Then lightly brush off the excess pastel to keep the first layers of pastel thin. The result looks like a thin stain of color.

MIDDLE DECISIONS:
THE PAINTING PROCESS

The painting process involves the selection of color and its application, and creating likeness.

It's necessary to work the likeness at every stage of the painting. If you haven't lost part of the likeness at each stage, it's probably because you're being too cautious in applying the layers of color. Drawing the features and carefully painting around them will not result in fresh integrated color, nor will it enable you to control your edges effectively. Don't worry. If you can get the likeness once, you can get it again. Likeness is a process, not an event.

2 | Paint the Local Color of Skin and the Darkest Darks

Select a middle-value grayed-down yellow-orange and stain the remaining areas of skin. This acts as the average ground from which you can modify the value, color and temperature of skin.

Select two very dark pastels: black and the darkest brown you can find. Using the black first, indicate the darkest area of the painting: the hair. Add the dark brown, allowing some of it to show on the paper and some to layer over the black. Finger-smooth as was done in the first step. These darks will basically remain unchanged through the painting, so it's not necessary to brush off the excess.

Select a very dark red that is similar in value to the brown you've just used in the hair but warmer in temperature. Use this stick to restate the likeness by indicating the shape and placement of the nostrils, the corners of the mouth and the shape of the eyes. Place both irises to establish the direction of the gaze.

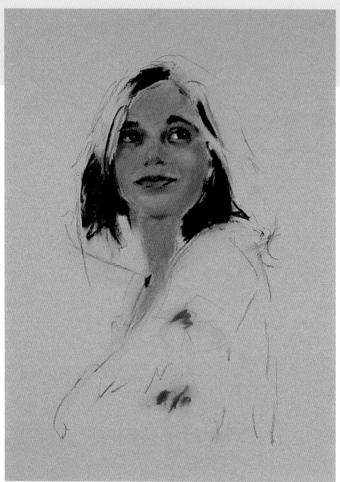

3 | Develop the Skin Tones

Begin the skin tones by adding lighter values to the stained base. Select two sticks with a similar middle-dark value and in complementary colors: slightly grayed-down red-orange and slightly grayed-down yellow-green. Restate the warmer downward-facing planes with the red-orange, then neutralize the saturation by layering the yellow-green on top. By stopping just short of the turn in the form, you'll leave the core of the shadow warmer and darker, adding volume to the form. Use this stick of yellow-green throughout the painting as a moderating and unifying color.

Select the seven remaining skin tone sticks: a middle-dark grayed-down red-violet; a grayed-down orange, grayed-down red and blue-green, all in middle values; a light grayed-down yellow; a middle-dark grayed-down yellow; and a middle-dark grayed-down violet. Place the colors by using the rules of temperature: lighter and cooler colors on the upward-facing planes; warmer and darker colors on the downward-facing planes. Touch the blue-green stick to the plane over the eyebrow on the right to reinforce the cool temperature of the skin in shadow. There are now fifteen sticks in your palette.

4 | Model the Eyes

In modeling the eyes, refine the shape of the sockets by placing the brows. Brows curve with the form of the forehead, and therefore are not uniform in color or value. Remember that photos will value-clump the darks, and will also fail to show color differences well in dark areas. When this happens, rely on what you know about color, value and how to make forms turn; use the very same principle in painting the eyebrows. The differences are extremely subtle, but important. The whites of the eyes change in both value and color across their surfaces, too.

One of the key visual clues about our subject's Indian sub-continent heritage is the pigment surrounding her eyes—its color, distribution and value. Likewise important is the deep, dark, lustrous quality of her hair, lashes and irises. In subjects whose irises are extremely dark, it's often necessary to use a coloration convention, as shown in the mini-demonstration on the next page. The same principles apply to light-eyed subjects.

a | Set Up the Eye

Paint the skin tones of the eye socket and lids, placing the iris to set the direction of the gaze.

b | Set Up the Iris

Paint the shape of the iris and pupil with black.

c | Paint the Iris

Indicate the iris with dark brown, leaving the outer ring of the iris and the pupil black.

d | Light the Iris

Paint the area of the iris opposite of the highlight (in this case, between seven o'clock and nine o'clock) with red-orange.

e | Paint the White of the Eye

Select a middle-light blue-gray stick to paint the area where the upper lid casts a slight shadow on the upper part of the white. Select a light grayed-down yellow-green (commonly called Raw Umber) to paint the lower part of the white of the eye.

f | Complete the Eye

Select a clear middle-dark red to lightly indicate the inner corner of the eye. Place the highlight opposite the red-orange part of the iris at about two o'clock, using a very light blue and an even lighter touch.

Getting the Likeness Right

In modeling the features, there are two schools of thought. Either bring the whole surface of the painting up slowly to the same degree of finish, or finish each section as you go and then move on to the next. When I began painting, I did the former, although now I'm more likely to work each section to near completion and then move on. It seems to help me control the likeness because once I get the first two things right, I have enough reference to get the third thing right, then the fourth and so on. I find it easier to manipulate one aspect of the likeness at a time. The only caution to this approach is that the first two things have to be really right, or any likeness errors will be badly compounded by the time you get to the end. It's a matter of personal temperament and technique. Experiment with what works best for you.

g | Complete the Right Eye (detail)

In order to retain the focal point of the painting, be sure that the eye on our right has shaper edges, greater contrast and richer color than the eye on our left.

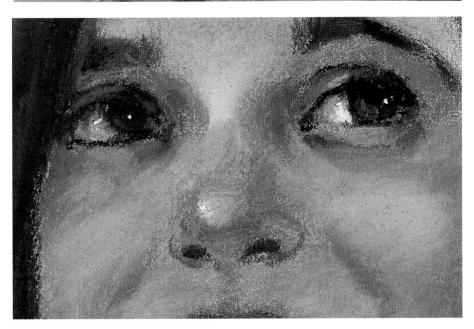

5 | Model the Nose (detail)

Recheck the shape and placement of the nostrils, and restate them with the very dark red if necessary. Use the dark grayed-down red stick to establish the edge where the tip of the nose turns under to meet the upper lip. Reduce the saturation just under the turning edge with the yellow-green stick. Use the dark grayed-down violet to declare the lateral planes to the nose, and the lighter cooler sticks to define the upper plane of the nose facing the sky.

6 | Model the Mouth (detail)

Recheck and restate the placement of the corners of the mouth. The upper lip is in shadow and also faces downward, so use the dark grayed-down red to indicate the shape of the upper lip, keeping the edges soft. The shape of the upper lip can be established with an additional layer of middle-dark grayed-down violet and the middle-value grayed-down red.

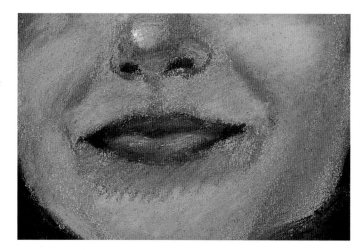

7 | Paint the Hair

Continue to use the black and very dark brown sticks to complete the shape of the hair in shadow. Select a very dark grayed-down blue-violet and middle-value blue to cool the color of the hair at the upper left side of the crown, where it reflects the blue sky. Select a middle-dark grayed-down orange to paint the plane of the hair where the light and shadow come together. Use a combination of white and middle-light yellow-orange to paint the areas of hair struck by direct sunlight. (The images on the next page show you how.)

| a | Paint the Three Values in the Hair | b | Create Texture by Controlling Edges | c | Add Pastel and Finish Texturizing |

a | Paint the Three Values in the Hair

Paint the hair in shadow with black and very dark brown. Use a middle-dark grayed-down orange to paint the turning edge of the form of the hair. Paint the light section of the hair with very light yellow and medium-light yellow-orange.

b | Create Texture by Controlling Edges

Using a clean finger (with or without a glove), make a single blending stroke in the direction of the strands of hair.

c | Add Pastel and Finish Texturizing

Add more color if you need it for blending. Continue to blend as above, one stroke per clean finger. If you need to make more than five blending strokes, wash your hands or get a new glove! Finish by warming the lower edges of the hair on the left using the same principles that landscape painters use for sky holes through tree branches: The areas where light just barely peeks through the hair should be a slightly darker orange than the color of the turning planes. Just blend it with a little very dark brown instead of adding another color to your palette.

The Finished Result

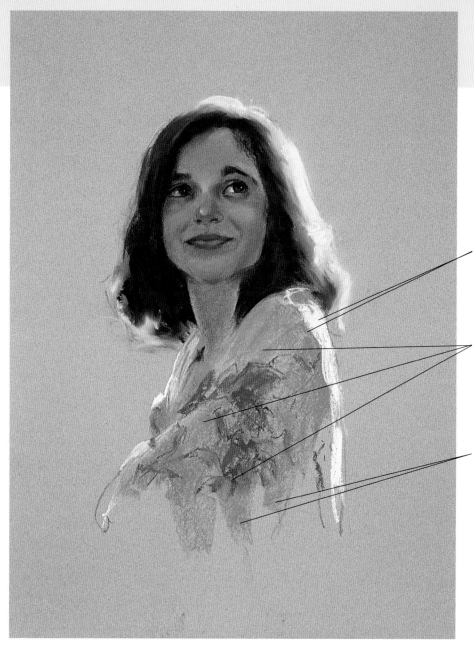

Use a variety of edges to support movement without changing the center of interest.

Use skin tones to integrate the shawl, skin color and lip color.

Find areas to integrate pastel with the background.

8 | Paint the Shawl With the Color of Light

Render the shawl loosely in an almost abstract fashion. By lightly applying the middle-dark grayed-down violet to the areas of the shawl in shadow, the gray of the paper shows through. For a vignette to work well, there must be places where the image is completely integrated with the paper or ground. This can be accomplished most effectively through disappearing edges. Arbitrary end points and abrupt value changes or edge shifts are extremely disruptive to the viewer's eye and can lend an amateurish quality to an otherwise successful painting.

Use white and light yellow to paint the shawl touched by sun. Leave the edge where shadow and light meet unblended. This edge is softer than the hardest edge in the eye on the right, but harder than the soft turning edge of the hair.

Add the last two colors to the palette to complete the pattern in the shawl: a middle-dark red-violet and a dark grayed-down blue-green. Use your yellow-green unifying color with the darker green in the leaves.

Final Decisions: Proofreading Your Portrait

- Is the center of interest clear? **Yes.**
- Is the composition effective?
 Does it support the viewer in
 finding the center of interest? **Yes.**
- Are color temperatures unified? **No.**
- Does the color harmony work? **Yes.**
- Are the edges well placed,
 supporting rather than competing
 with the center of interest? **Yes.**
- Is a discord needed? **No.**
- Is there an optimal place
 for the signature? **Yes.**

 The only thing left to do is sign it, frame it and put the nail in the wall.

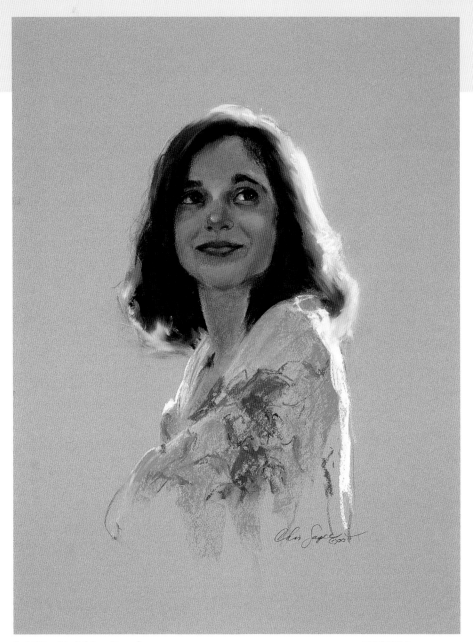

9 | The Finishing Touches

The last task in painting the shawl is to integrate its colors with the rest of the painting. In truth, adjacent colors impact each other. In this case, the white shawl would reflect some cool blues into the underside of the jaw, and the skin would reflect some orange onto the top of the shawl around the neck. In order to underscore the sense of color temperature in this painting; however, it's best to make a choice about which reflected color should dominate (the principle of unequal balance). Rather than introducing cool tones in the downward-facing planes of the face, I've chosen to add orange into the upward-facing planes of the shawl.

MANISHA
Pastel on Canson paper
22" x 16" (56cm x 41cm)
Collection of the artist

Skin Tone, Hispanic

Materials List

- Surface: 18" x 14" (46cm x 36cm) Belgian linen canvas
- 6B charcoal pencil
- Brushes: variety of bristle filberts, nos. 2 through 12; sable brushes for blending, any size
- Turpenoid
- Standard oil palette (see page 70), plus Permanent Rose

nergy, beauty and charisma all come together in a portrait of this talented young actress. Engage your viewer by painting your model with a straight-on facial position and direct gaze, and create the illusion that the subject's eyes follow the viewer wherever he stands. Tasha's orange skin is middle-light in value, and grayed down with greens and blues. Her dark eyes, brows and hair reflect her Hispanic heritage.

Compose the Portrait With a Three-Value Thumbnail Sketch

Use a value plan to work out light, middle and dark shapes, size and subject placement. When you work on a surface with a fixed size, it's essential to place your subject correctly at the start. Remember that the rabbet (rebate) will cover ⅜" (10mm) all around, so avoid tangents in the corners and sides, and be careful not to crowd the head at the top of the canvas. Be sure that your value sketch is proportional to the canvas, and mark the center.

EARLY DECISIONS: THINK BEFORE YOU PAINT

- **Identify the center of interest.** To make Tasha's compelling gaze the center of interest, both eyes need to be treated equally. In this way, the viewer will be enticed into looking back and forth from eye to eye.
- **Determine the compositional design.** Use a three-value thumbnail sketch to work out a value plan, the distribution of the negative spaces and the placement of the subject on the canvas. This portrait is a painting about light, since only about 15 percent of the surface area will be dark.
- **Determine the color of light.** Photos taken outdoors under a patio roof resulted in a flat indirect light, blocking both the cool blue light from the sky and direct yellow sunlight. The Kelvin temperature in these photos was probably in the middle, about 8500K, which is similar to light on a hazy day. Flat neutral light offers very little temperature differences between light and shadow—it's boring to paint and boring to view. As the artist, you need to decide how you'd like to push the color temperature—go one way or the other, but don't sit on the fence. For this demonstration, assume that the light is cool and the shadows are warm.
- **Determine the color harmony.** Strong reds and red-violets in Tasha's dress suggest a red-green complementary color harmony, easily accomplished with green foliage.

Flat Light: The Artist's Choice
Where light and shadow are close in value and temperature, you can make a conscious choice to pick a color temperature for the light source. This pair of resource photos, shot in quick succession, allows the best facial expression and body language to be combined.

MIDDLE DECISIONS:
THE PAINTING PROCESS

1 | Prepare the Canvas and Draw the Portrait

Tone the canvas with Terre Verte thinned down with Turpenoid. Mark the center with a 6B charcoal pencil to correspond to the center of the thumbnail sketch.

Next, use a no. 2 bristle filbert brush to draw the portrait with Terre Verte, following the placement worked out in the thumbnail.

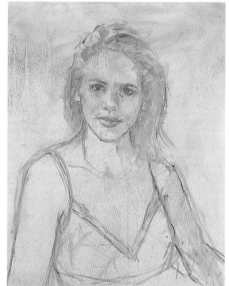

2 | Commit to the Background

Loosely placed greens, yellow-greens and blue-greens create the impression of foliage. Getting the background placed early is important to the painting because it establishes a value against which other values can be judged, and a color against which other colors, especially skin tones, can be judged.

Mix some dark to middle-value greens from Cadmium Lemon, Phthalo Green, Ultramarine Blue and Titanium White. Neutralize some of them with Alizarin Crimson. Move some background color into the edges of the hair for soft transitions later on. Notice how Phthalo Green changes dramatically with even tiny additions of Titanium White, so add it sparingly.

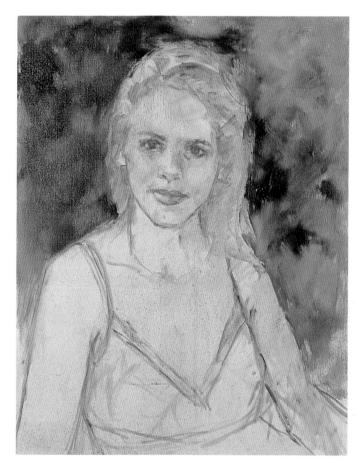

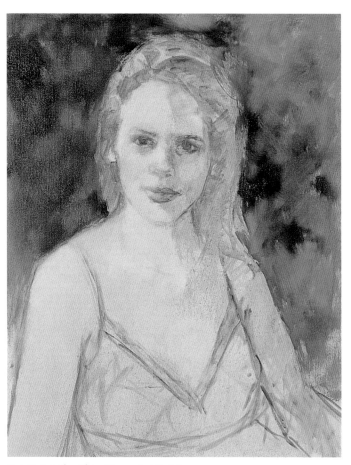

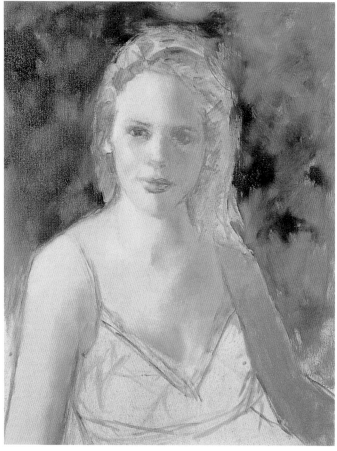

3 | Paint the Skin Tones in Light

Lightly scrub in lights with a no. 4 bristle filbert, following your cool light source assumption. Upward-facing planes will pick up ambient blue from the sky; sideward-facing planes will reflect green from the foliage; and downward-facing planes will be a little warmer, influenced by the dress, the earth and, of course, the cool light source.

Mix several hues and temperatures to represent the average color and value of skin in light. Neutralize a base of Titanium White and Permanent Rose with Phthalo Green and Cadmium Lemon. Add Cadmium Scarlet.

4 | Paint the Skin in Shadow

Lightly paint in the shadow pattern. The transition from light to shadow is most subtle in the forehead. Use a dry sable brush to blend the edges while they're still wet.

Mix several warmer, grayed-down hues to approximate the average color and value of the skin in shadow.

Drawing the Portrait in Oil

Take the drawing as far as necessary to feel comfortable moving into color. It's often helpful to make a more complete drawing when your resource photos are flat, as in this case. The Terre Verte drawing, easy to erase with Turpenoid, helps you explore the structure of the face that is not readily apparent from the photographs. Although the likeness will be lost many times throughout the painting process, this visual dress rehearsal makes it easier to regain it. This thin drawing can sit for hours or days, and gives you a chance to find errors that you can correct once you begin using color.

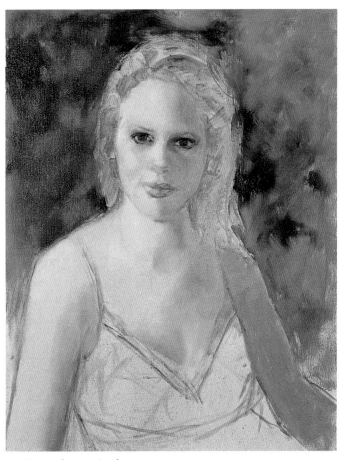

5 | Paint the Eye Sockets

Mix warm and cool dark browns with Cadmium Scarlet and Ultramarine Blue. Use a small bristle filbert (no. 2 or 4) to first model the shape of the eye socket, loosely placing the irises. You can correct the gaze later. Model both eyes at the same time.

6 | Complete the Eyes (detail)

Paint the whites of the eyes in a grayed-down neutral mixed with Titanium White, Ultramarine Blue, Phthalo Green and Cadmium Lemon. The whites of the eyes get a small cast shadow under the upper lashes that is mixed from Ultramarine Blue and Titanium White. Paint the irises from three o'clock to six o'clock with a warmer, lighter brown; the pupil is a spot of black, mixed from Phthalo Green and Alizarin Crimson. Place tiny catch lights at ten o'clock, keeping them small. Keep focused on the eyes as your center of interest, with sharper edges, greater contrast and saturated color.

Be Cautious with Phthalo Green

Typically, this is where you'd want to place your darkest darks, which would include the hair. Since there's so much Phthalo Green in the background, give it a few hours to set up a little before painting into it. Otherwise, it's easy to accidentally pick up and transfer Phthalo Green into other undesirable places. The eyes can adequately describe the darkest dark. If you have trouble controlling the Phthalo Green, try Viridian instead.

7 | Model the Nose, Place the Brows (detail)

Paint the nose with variations of colors you've already mixed—cooler where the light strikes most directly; warmer and darker at the shadow's core. Compare the turning edge of the nose to the softer turn of the forehead and the sharper edges in the eyes. A fleck of Alizarin Crimson places the nostrils. The edge at the top of the nostril is sharper than the edge at the bottom.

It's often easier to place the eyebrows, which are so important to likeness, after you have painted the nose. Then you have both corners of the eyes as well as the wings of the nose as helpful landmarks.

8 | Model the Mouth (detail)

Use a variety of reds, red-oranges and red-violets to paint the mouth. Touch the corners with Alizarin Crimson, and paint the highlight in a light cool red. The placement and shape of the light on the lower lip will define the shape of the mouth, so it must be considered carefully.

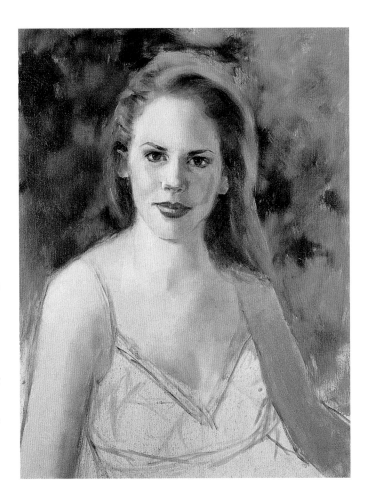

9 | Paint the Hair

Squint at the hair to find its three basic values, just as you'd approach the three-value thumbnail sketch. Use the same browns you mixed for the eyes, painting the general shapes. Keep the hairline very soft where it meets the skin. Use large, loose strokes to integrate lost and found edges where the hair meets the background. Exaggerate temperatures if you'd like—after all, this is a painting, not a photograph! Use grayed-down blues and blue-violets to paint the areas of hair in light.

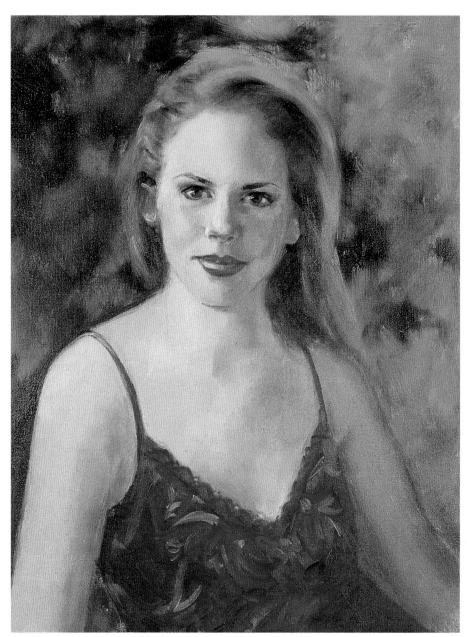

10 | Paint the Dress

Paint the dress in its dominant color and value: middle-value, slightly grayed-down red-violet. Darken and gray down areas of the dress in shadow by brushing background greens over the reds. Paint the pattern on top of the overall color.

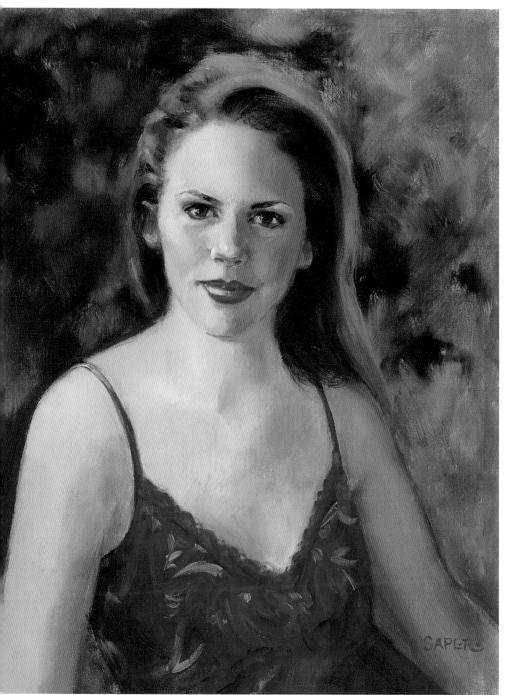

FINAL DECISIONS: PROOFREADING YOUR PAINTING

- Is the center of interest clear? **Yes.**
- Is the composition effective? **Yes.**
- Are color temperatures unified in shadow and light? **Yes.**
- Is the color harmony effective? **Yes.**
- Are the edges stated effectively?

 Not quite. While the edges support the center of interest, the hair is too uniformly soft to balance the pattern in the dress. Add dark, crisp accents to improve balance and add secondary edge interest.
- Is there an optimal place for the signature? **Yes.**

 By making painting decisions at the right time, the finishing problems can all be easily dealt with. Even small likeness adjustments can be made at the end. Moving something just a smidgen can make an enormous difference in likeness.

11 | Make Proofreading Corrections

Correct the likeness by broadening the face at the cheekbones. Correct the values by darkening the shadowed side of the face. Enliven the hair with brushwork and dark accents. Sign the painting.

PORTRAIT OF TASHA DIXON
Oil on canvas
18" x 14" (46cm x 36cm)
Collection of the artist

Skin Tone, Caucasian

Materials List

- Paper: Arches 140-lb. (300gsm) cold-press, 16" x 12" (41cm x 30cm), stretched
- Brushes: 1-inch (25mm) flat sable; no. 8 round sable
- No. 2 pencil
- Kneaded eraser
- Standard watercolor palette (see page 80), plus Cadmium Red
- Masking fluid
- Razor blade to lift out highlights

Finished Painting

Painting Ashlee in watercolor was a delight. Watercolor is well suited to her translucent complexion, clear blue eyes and light blond hair. Her skin is orange, light to middle-light in value, and only very slightly grayed down with green.

EARLY DECISIONS: THINK BEFORE YOU PAINT

- **Identify the center of interest.** Ashlee's right eye (our left) catches the light and will be the point of greatest impact. Sharpest edges will be in this eye, with secondary edges in the background and shine of her hair.
- **Determine the compositional design.** In watercolor vignettes, you can let the clean white paper balance the image. This is a great opportunity to paint a high-key painting, where all of the values (except tiny accent areas) are middle-value or lighter, and you use temperature, saturation and edges to create dimension.
- **Determine the color of light.** Although the light is filtered and diffused, it's clearly warm, letting the shadows cool.
- **Determine the color harmony.** Ashlee's peaches-and-cream coloring would easily support an analogous orange color scheme accented with discords. However, a yellow-violet complementary color harmony would be more interesting, particularly since there will be a substantial amount of white left on the surface.

1 | Draw the Portrait

By using a no. 2 pencil to place the head centered left to right and slightly closer to the top than the bottom of the paper, you'll keep a little wiggle room for cropping when you're finished. Draw the portrait to the level of completion you prefer. Now, erase the drawing with a kneaded eraser, leaving just a ghost of the drawing.

The Importance of Drawing

Of the three mediums shown in this book, watercolor is the least amenable to being changed. Therefore, I recommend spending more time in the drawing phase than you might in the other two mediums. When you paint watercolor portraits from life, try using the entire first modeling session to get your likeness established. In painting from photos, take as much time as you'd like, but avoid the temptation to overwork the drawing!

Middle Decisions: The Painting Process

During the process of painting, you'll be working on both likeness and color mixing. Since watercolor can be easily overworked, it's usually easier to establish your likeness before you begin to apply color.

To Mask or Not?

Using masking fluid is a highly personal choice. It's a lifesaver to escape that "painted around" look that is often characteristic of overworked or amateurish paintings. The downside is that it invariably leaves uniformly sharp edges once it's removed. Get the best of both worlds by limiting masking to areas that not only need to stay very light, but whose sharp edges you want to preserve. Experiment—after all, it's just a piece of paper!

2 | Apply Masking and First Wash

Preserve the white of the paper in the areas of highest value: the eye in light (including catch lights) areas of its socket, and the highlights on the nose, lower lip and hair.

Use a 1-inch (25mm) flat sable brush to wash the skin areas in Raw Sienna. Allow the wash to move through the hair and into the background. Drop a small amount of Rose Madder Genuine into the cheek in the light. Let it dry. This wash's value should match the average value of the skin in light, but should be dark enough to easily see the masking.

3 | Paint the Skin in Shadow

Wash in the shadow shapes, starting at the forehead, with greens (Aureolin + Viridian) moving to red-violet (Rose Madder Genuine + Cobalt Blue) below the eyebrow. Drop a small amount of Rose Madder Genuine into the wet cheek area. Let it dry.

4 | Adjust the Value of the Skin in Shadow

Darken the skin in shadow with another wash of red-violet and red. Establish the jawline in shadow, keeping the edges soft.

5 | Model the Structure of the Face in Light

Switch to the round sable brush. Wet the cheek in light, then apply a light wash of Rose Madder Genuine to the area of the cheek where it meets the wing of the nose, the lips and the turning plane where the lower eye socket meets the upper cheek. Soften the edges where needed while the paper is still wet. Let it dry.

6 | Model the Structure of the Face in Shadow

Use a darker version of the red-violet you've already mixed to place areas of darker shadow. Some of these shadows will go into the inner corner of the eye socket in light.

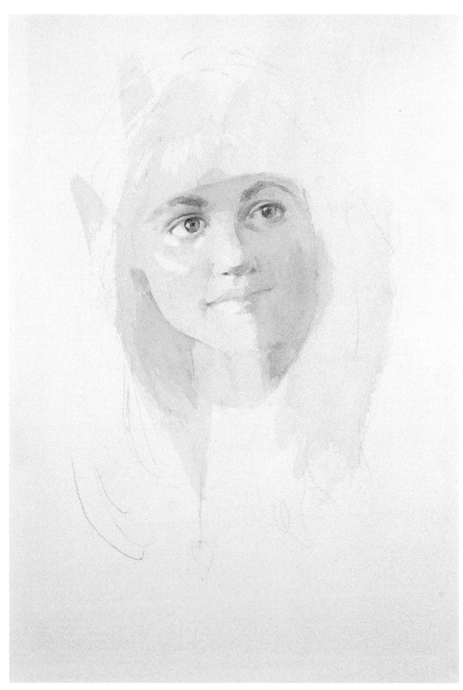

7 | Paint the Eyes in Three Stages

This is how the eyes should look when completed.

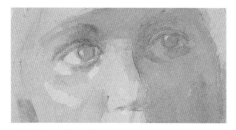

a | Place the Irises

Paint the irises and cast shadows under the upper lashes in Cobalt Blue. Placing the irises sets the gaze. If you're unsure about placement, work it out with your pencil first. Let it dry.

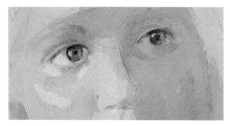

b | Complete the Irises

Adjust the value and hue of the irises with Cobalt Blue. Remember that the catch light (here, at ten o'clock) sits in the darkest part of the iris; the lightest part is opposite at about four o'clock. Although the entire eye on our right is in shadow, the value relationships at ten o'clock and four o'clock still hold. Let it dry.

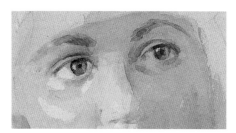

c | Complete the Lids and Brows

Use a mix of Cobalt Blue and Burnt Sienna to paint the brows. To keep their inner corners soft, wet them first. Restate the creases in the upper lids, observing the three principles of shadow: lower contrast, lower saturation and softer edges. Let it dry.

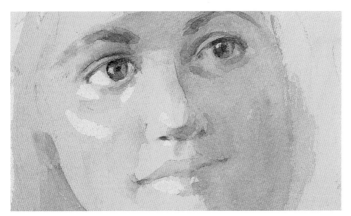

8 | Model the Nose (detail)

Indicate the nostril with a tiny stroke of Alizarin Crimson. Wet and then paint where the nose turns under to meet the lip with a touch of Cadmium Red and Aureolin. This is now the warmest area of skin color on the paper. The nostril in shadow has cooler, less saturated color than in light and the edges are softer, too.

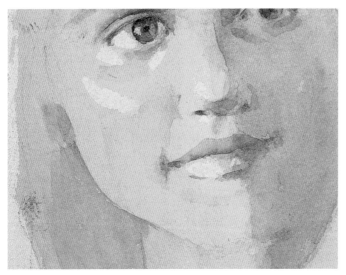

9 | Model the Mouth (detail)

Keep the upper and lower edges of the lips soft by wetting the edge before painting. Using Rose Madder Genuine, start on dry paper at the edge between the lips and let the color flow toward the outer edges. While the paper is still wet, cool the lip in shadow with Alizarin Crimson.

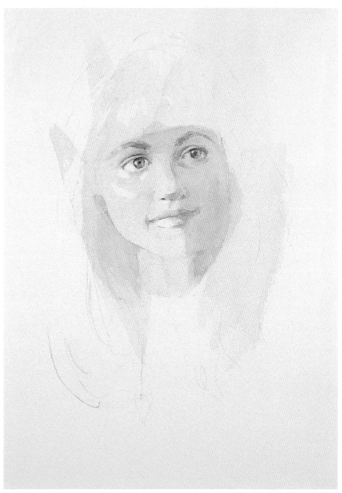

The Finished Result

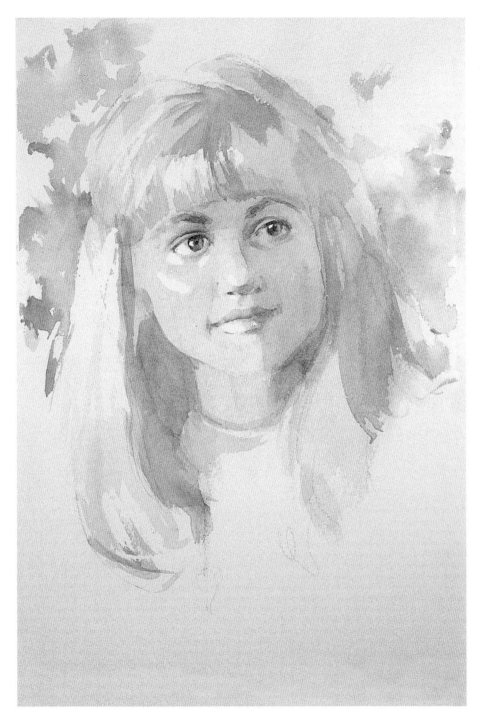

10 | Paint the Hair and Background

Paint both in the same step so that you can work in some lost and found edges where the shapes meet. Paint the hair in light with different strengths of Raw Sienna. As the hair moves into shadow, gradually add Burnt Sienna. Where the hair is completely in shadow, neutralize the Burnt Sienna with Cobalt Blue and Viridian.

To unify color, paint the background with red-violets and blue-violets already used elsewhere. Let your edges vary to create supporting secondary edges and impart a lively sense to the surface.

Remove the masking before proofreading.

Final Decisions:
Proofreading the Painting

- Is the center of interest clear? **Yes.**
- Is the composition effective? **Yes.**
- Are the color temperatures correct? **Yes.**
- Are the edges well-stated?
 No. The areas covered by masking are all
 the same white, and the edges are the
 same. Most need to be softened and
 colored. Also, the catch light in the
 shadowed eye is simply in the wrong
 place. It needs to be painted out and, once
 dry, repositioned with a scratch from a
 razor blade.
- Is the signature needed? **Yes.**

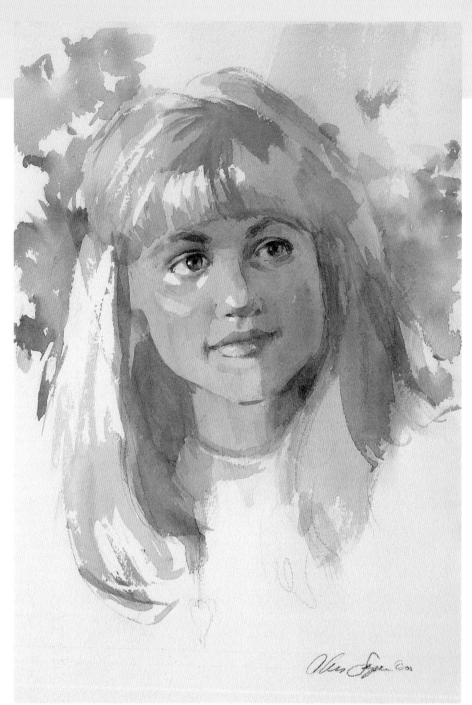

11 | Make Final Corrections

Most of the remaining tasks involve correct-
ing or mitigating masked areas. Place the
signature with pencil.

ASHLEE
Watercolor on Arches
 cold-pressed watercolor
 paper
15" x 10" (38cm x 25cm)
Collection of the artist

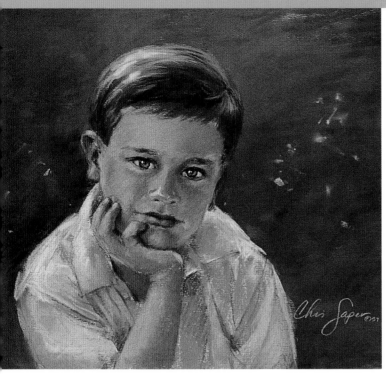

GOLDEN EYES
Pastel on Canson paper
16" x 20" (41cm x 51cm)
Collection of the artist

This is, in fact, the beginning. I hope the tools and lessons presented in this book will help you move forward from wherever you are today.

If the truth be known, some of the finest painters will tell you that their work is only about 15 percent a result of inborn talent; the larger part is a result of good training and practice, practice, practice. Michelangelos, Vermeers and Sargents come along once in a century. Will you paint like them? Probably not. Neither will I. Be inspired, not discouraged. Be the best painter you can be. There's no substitute for putting in the hours.

It's a beautiful world out there. Grab your brushes. Someone has to paint it, and it might as well be you.

CONCLUSION

Recommended Resources

Tools and Supplies

Analogous Color Wheel—Hal Reed
Art Video Productions
P.O. Box 92343
Pasadena, California 91109
(888) 513-2187
www.artvideostore.com

Wallis Archival Sanded Pastel Paper
(800) 760-7870

Quiller Color Wheel
Quiller Gallery
P.O. Box 160
Creede, Colorado 81130
(800) 876-5760

The Michael Wilcox School of Colour
Gibbet Lane
Whitchurch
Bristol BS14 0BX
United Kingdom
Tel: 01275 835500
Fax: 01275 892659
www.schoolofcolor.com

Books

Dobie, Jeanne. *Making Color Sing*. New York: Watson-Guptill, 1986.

Kreutz, Greg. *Problem Solving for Oil Painters*. New York: Watson-Guptill, 1986.

Quiller, Stephen. *Color Choices*. New York: Watson-Guptill, 1989.

Schmid, Richard. *Alla Prima: Everything I Know About Painting*. Longmont, Colorado: Stove Prairie Press, 1998. West Wind Fine Art & Antiques, (800) 939-9932.

Silverman, Burton. *Sight & Insight*. New York: Madison Square Press, 1998. Merrill-Johnson Gallery, (303) 333-1566.

Whitney, Richard. *Painting the Visual Impression*. 1995. Minnesota River School of Fine Art, 190 River Ridge Circle, Burnsville, Minnesota 55337, (612) 890-4182.

Videos

Greene, Daniel. *Pastel Portrait*. LeFranc & Bourgeois, 1989. (914) 669-5653.

Silverman, Burton. *Painting the Figure in Watercolor*, Signilar Art Video, 1996; *Portrait of a Young Girl: Jenny (oil)*, Signilar Art Video, 2000. (800) 205-4904.

Kelvin Temperatures for Portrait Painters

Natural Light		Artificial Light	
Clear Blue Sky	12000+	Xenon Arc	6420
Hazy Sky	7500	Camera Flash	5500
Noon Sunlight	6500	3200 Tungsten	3200
Sunlight at 10:00 am and 2:00 pm	5500	Halogen	3000
Sunrise and Sunset	2200	500 Watt Incandescent	2960
		100 Watt Incandescent	2865
		40 Watt Incandescent	2650
		Candlelight	1900

Unless artificial light is specifically rated, temperatures are approximate.

Sources: Kodak: www.kodak.com; Kodak Color Films & Papers for Professionals, 1996; The Photographer's Guide to Using Filters, Joseph Meehan, 1992.

Sample Color Charts

For each skin tone group, mix enough base
color to add other modifying colors as
suggested. Caucasian skin tones (blondes,
redheads and brunettes) all use the same
three colors as a starting point. Change
proportions to match the skin color of any
given individual.

CAUCASIAN SKIN TONE SAMPLES

Base	Cool Light	Warm Shadow	Warm Light	Cool Shadow
CS + CL + TW + PG	+ PR + UB + TW	+ CS + AC	+ PR	+ UB + AC
	+ PR + TW	+ CS + UB	+ CL	+ PG + CL + CS

Key

AC = Alizarin Crimson
CL = Cadmium Lemon
CS = Cadmium Scarlet
PG = Phthalo Green
PR = Permanent Rose
TW = Titanium White
UB = Ultramarine Blue
UV = Ultramarine Violet

Asian Skin Tone Samples

Base	Cool Light	Warm Shadow	Warm Light	Cool Shadow
CS + CL + TW + UB + CL	+ PG + CL + TW	+ PG + CL + PR + TW	+ CS + CL	+UB + TW
	+ PG + CL + AC	+ CS + PG	+ CL	+ AC + UV

Key

AC=Alizarin Crimson
CL=Cadmium Lemon
CS=Cadmium Scarlet
PG=Phthalo Green
PR=Permanent Rose
TW=Titanium White
UB=Ultramarine Blue
UV=Ultramarine Violet

HISPANIC SKIN TONE SAMPLES

Base	Cool Light	Warm Shadow	Warm Light	Cool Shadow
AC + CL + TW + UV	+ TW + AC	+ CS + PG	+ CL + TW	+ UV
	+ PG + CL + TW	+ PG + CL	+ CL + PG + CS	+ AC + UV

Key

AC=Alizarin Crimson
CL=Cadmium Lemon
CS=Cadmium Scarlet
PG=Phthalo Green
PR=Permanent Rose
TW=Titanium White
UB=Ultramarine Blue
UV=Ultramarine Violet

Black/African-American Skin Tone Samples

Base	Cool Light	Warm Shadow	Warm Light	Cool Shadow
CS + UB	+ AC + PG + UB + TW	+ CS + IB	+ UB + CL	+ UB
	+ TW	+ CL + IB	+ CS + CL	+ PG

Key

AC=Alizarin Crimson
CL=Cadmium Lemon
CS=Cadmium Scarlet
IB=Ivory Black
PG=Phthalo Green
PR=Permanent Rose
TW=Titanium White
UB=Ultramarine Blue
UV=Ultramarine Violet

Index

Make Your Art the Best It Can Be!

From à la poupée to Zinc White, more than one thousand art-related definitions and descriptions are detailed here for your benefit. Including every term, technique and material used by the practicing artist, this unique reference is packed with hundreds of photographs, paintings, mini-demos, black-and-white diagrams and drawings for comprehensive explanation. You'll also find sidebars about specific entries and charts for a wealth of inter-related information in one convenient listing.

1-58180-023-1 (US ISBN), 0-7153-1242-1 (UK ISBN); paperback, 512 pages

This book gives you the confidence and skill you need to make the most of every second you spend painting. You'll learn a variety of timesaving techniques, create simple paintings in sixty minutes, then attack more complex images, breaking them down into a series of "bite-sized" one-hour sessions. Includes twelve step-by-step demos!

1-58180-035-5 (US ISBN), 0-7153-1243-X (UK ISBN); paperback, 128 pages

Using a few brushes, some rice paper and a small number of inks and paints, you can explore new realms of artistic expression in your watercolors. Author and artist Lian Quan Zhen shows you how, providing you with the clear, practical instruction you need to master every element of this intriguing style—from holding a bamboo brush to applying Chinese composition techniques.

1-58180-000-2 (US ISBN), 0-7153-1159-X (UK ISBN); hardcover, 144 pages

Charles Reid is one of watercolor's best-loved teachers, a master painter whose signature style captures bright floral still-lifes with a loose spontaneity that adds immeasurably to the whole composition. In this book, Reid provides the instruction and advice you need to paint fruits, vegetables and flowers that glow. Special "assignments" and step-by-step exercises help you master techniques for wild daffodils, roses, mums, sunflowers, lilacs, tomatoes, avocados, oranges, strawberries and more!

1-58180-027-4 (US ISBN), 0-7153-1208-1 (UK ISBN); hardcover, 144 pages